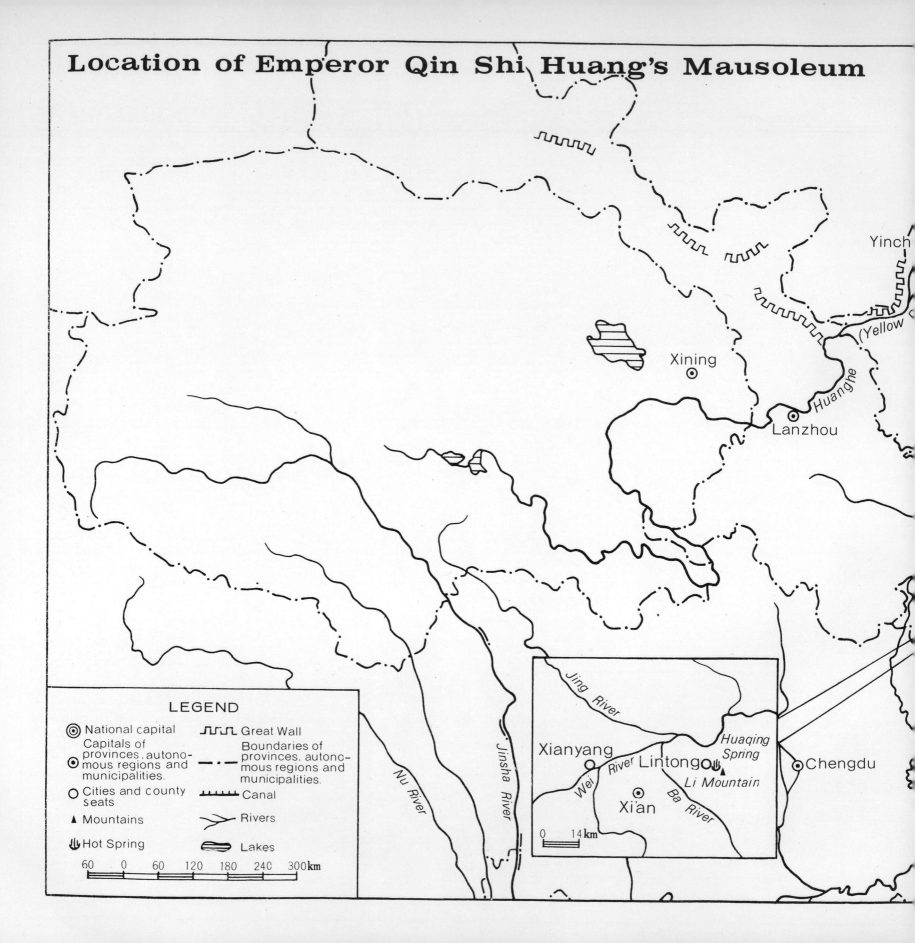

Location of Emperor Qin Shi Huang's Mausoleum

Yinch

Xining

Lanzhou

Huanghe

(Yellow

LEGEND

◎ National capital

◉ Capitals of provinces, autono-mous regions and municipalities.

○ Cities and county seats

▲ Mountains

♨ Hot Spring

ᓬᓬᓬ Great Wall

–·–·– Boundaries of provinces, autono-mous regions and municipalities.

⊥⊥⊥⊥ Canal

➤ Rivers

⬭ Lakes

Nu River

Jinsha River

Jing River

Huaqing Spring

Xianyang

Wei River

Lintong

Li Mountain

Xi'an

Ba River

Chengdu

0 14 km

60 0 60 120 180 240 300 km

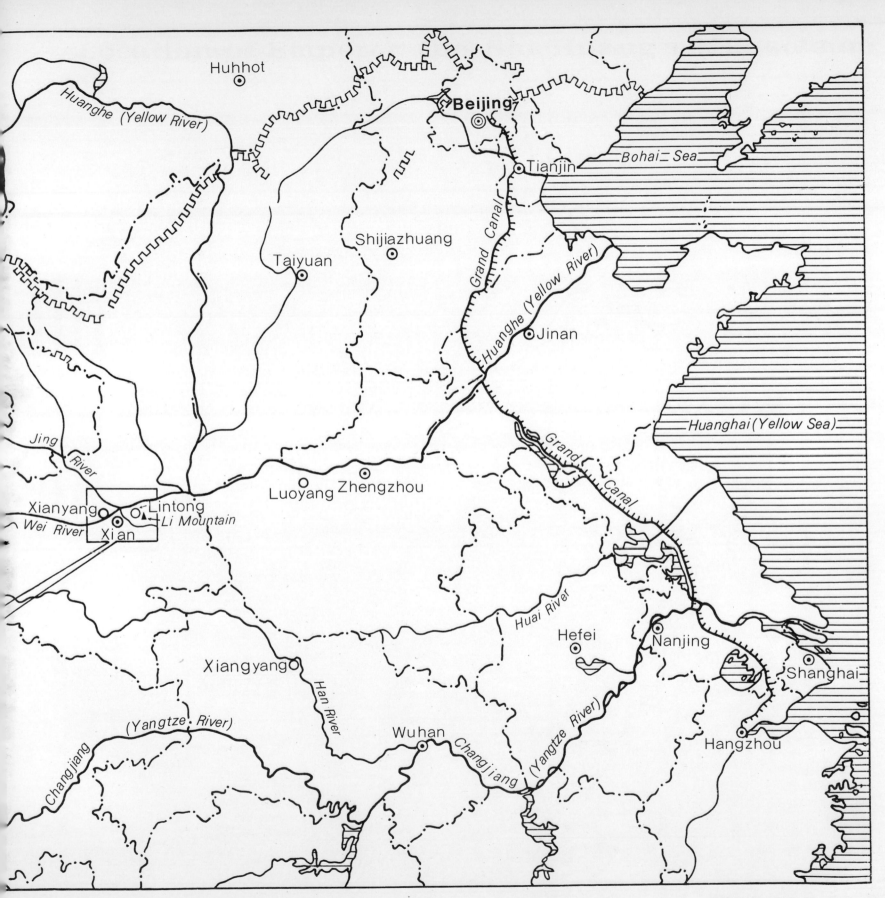

Map by Yin Zinan

THE UNDERGROUND TERRACOTTA ARMY
OF EMPEROR QIN SHI HUANG

Edited by Fu Tianchou

Introduction by Sidney Shapiro
Text by Fu Tianchou

NEW WORLD PRESS
Beijing, China

First Edition 1985
Fifth Printing 1992

Photographs by Weng Naiqiang, Wang Lu, Wang Jingren, Li Xing, Wang Tianyu and others
Maps and illustrations by Yin Zinan and others
Color sketches by Fu Tianchou
Book design by Li Yuhong

ISBN 7-80005-009-2

Published by
NEW WORLD PRESS
24 Baiwanzhuang Road, Beijing, China

Distributed by
China International Book Trading Corporation
35 Chegongzhuang Xilu, Beijing 100044, China
P.O. Box 399, Beijing, China

Printed in the People's Republic of China

CONTENTS

FOREWORD

The discovery of the terracotta army of Qin Shi Huang, the First Emperor of the Qin Dynasty (221-206 B.C.), is regarded as one of the most spectacular archaeological finds of the 20th century. Since the opening of the Museum of Qin Shi Huang's Terracotta Warrior and Horse Figures in 1979, hundreds of thousands of people from all over the world have travelled to Lintong County near Xi'an to view the excavation site and the figures with their own eyes. Yet there are countless more who, having read about the terracotta army in magazines or heard about it from friends, desire to know more about it and obtain a glimpse of the magnificence of its sculptural art.

It is the purpose of the present book to offer the reader, in both words and pictures, a comprehensive introduction to this more than 2,000-year-old monumental group sculpture. Professor Fu Tianchou, Head of the Department of Sculpture at the Central Academy of Fine Arts in Beijing and a distinguished sculptor and art critic, has been carrying out exhaustive research on the findings from the excavations since 1974. His essay "The Art of the Terracotta Warrior and Horse Figures" combines scholarly thoroughness with a sculptor's appreciation of the excavated figures. The introductory essay by Sidney Shapiro, author of the autobiographical *An American in China* and translator of the famous classic Chinese novel *Outlaws of the Marsh*, gives essential background information about the First Emperor and the excavation of the terracotta army.

The unique collection of photographs in this book provides full pictorial documentation of the underground terracotta army. With his "sculptor's eye," Professor Fu has selected these pictures and personally supervised much of the photography, thus ensuring both accuracy of depiction and visual beauty.

New World Press

Sidney Shapiro

The First Emperor of China and His Tomb Figures

The imperial tomb of Qin Shi Huang (259-210 B.C.), the first emperor of China and founder of the short-lived Qin (Ch'in) Dynasty (211-206 B.C.), lies 35 kilometers east of the city of Xi'an, in Lintong County, Shaanxi Province.

The tomb was 36 years in the building, having been commenced one year after Ying Zheng, the future first emperor, became head of the state of Qin in 246 B.C. The mausoleum was part of the lavish construction program which characterized his reign.

Achievements of Emperor Qin Shi Huang

By 221 B.C., King Zheng annexed the six other independent kingdoms of the Warring States Period (403-221 B.C.) and founded the first unified feudal empire in Chinese history, proclaiming himself Shi Huang Di, or the First Emperor of the Qin Dynasty.

Emperor Qin Shi Huang was a man of remarkable talents and achievements. His military conquests were in part the result of a superb mastery of the newest arts of war. He abolished the system of feudal enfoeffment and created a form of centralized, autocratic government which was maintained in essence to the fall of the last (Qing) Dynasty in the early 20th century. He promulgated a uniform code of law and standardized currency, weights and measures, the written language and the axle length of wagons and chariots. He built a vast network of tree-lined roads 50 paces wide, radiating from the Qin capital, Xianyang, 20 kilometers northwest of Xi'an. He joined into a single 3,000 kilometer "Great Wall" (extended to 6,000 kilometers during later dynasties) the separate walls erected by the earlier northern states to deter the raiding nomadic tribes.

Palaces for the Living and the Dead

For his personal glorification, Emperor Qin Shi Huang built a number of elaborate palaces, the largest of which was the E Pang Palace situated in the southwest of present-day Xi'an. The reception hall of this legendary palace was some 1,000 meters long and over 150 meters wide, and could hold 10,000 people. Several hundred thousand laborers were conscripted for the construction of the palace. The only other colossal undertaking that matches this magnificent palace was the First Emperor's mausoleum.

On the slopes of Li Mountain and to the south of the Wei River, the tomb mound, now 76 meters in height and 1,250 meters in perimeter, was originally enclosed by rectangular inner and outer walls respectively 4 and 6 kilometers in perimeter.

Although the entire mausoleum remains to be explored and excavated, we know from written records that it was an underground palace complex. According to Sima Qian, who wrote his ***Records of the Historian (Shiji)*** some 100 years after the First Emperor's death, the ceiling of the tomb chamber is a model of the heavens and its floor a map of the empire; jewels and other treasures buried within are guarded by devices triggered to release arrows at any intruder; and the workmen who installed the finishing touches were buried alive to ensure that the secret of the entranceway died with them.

If this is all true, the underground sepulcher is indeed in keeping with the grand style maintained by the First Emperor during his lifetime. Archaeologists have long suspected that there must be more to the imperial interment than what Sima Qian described. In the Zhou Dynasty (c. 1066-256 B.C.), members of the aristocracy were buried

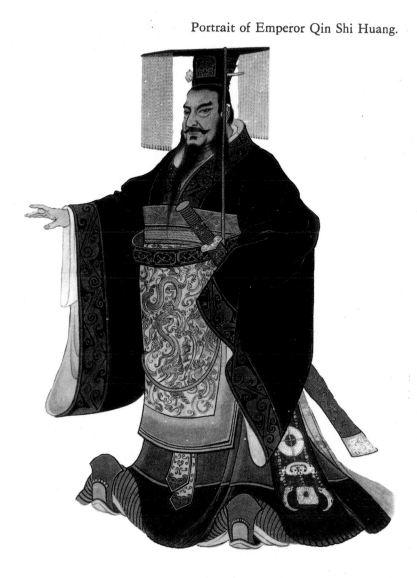
Portrait of Emperor Qin Shi Huang.

number of fragments of terracotta warriors and horses which experts identified as dating from the Qin Dynasty. The area now called Pit No. 1 was placed under the protection of the central government's Bureau of Historical Relics, while the task of excavation was entrusted to Shaanxi Provincial Committee for the Protection and Preservation of Historical Relics.

Following the discovery of Pit No. 1, Pits No. 2 and No. 3 were found in May and June 1976 respectively.* These two pits were also excavated but were refilled with soil later. Excavation shows that all the three pits of lifesize pottery figures were originally roofed over and lined with a framework of earth and wood which collapsed long ago. The first two pits were damaged in a fire (possibley razed by the rebel forces under Xiang Yu, who is said to have set the palaces and tomb of Emperor Qin Shi Huang on fire after defeating the Qin forces), while the third pit caved in by itself. As a result, most of the pottery figures were reduced to fragments.

A still more recent and amazing find at the site of the First Emperor's mausoleum was a pair of four-horse chariots, each with a charioteer, all cast in bronze. These artifacts were unearthed in December 1980 some 17 meters to the west of the tomb mound.

Pit No. 1

Pit No. 1 is 230 meters from east to west, 62 meters from north to south, 5 meters deep, and covers an area of 14,260 square meters. Five ramps of rammed earth lead down into the pit from the east, 5 from the west, 2 from the north, and 2 from the south. Rows of wooden pillars and beams laid between thick earthen walls form roofed trenches or corridors, which were covered over first with woven mats and then with alternate layers of plaster and earth up to ground level. The floors are paved with the famous Qin bricks, which possess an extraordinary strength and durability. Both the corridors and the earthen dividing walls are roughly 3 meters wide.

Within these corridors stands a veritable terracotta army. To date, the main work of excavation has been carried out on the east end of Pit No. 1, bringing to light over 1,000 warrior figures and 24 horse figures, a small fraction of the 6,000 the pit is estimated to contain. The warriors average 1.8 meters high. The horses, which stand 1.5 meters high and 2 meters long, are divided into teams of four, each team pulling a single wooden chariot.

Standing in the front corridor is a vanguard facing east which is made up of 3 rows of 70 warriors each. Immediately behind them are 38 columns in 11 groups facing east (the figures in each corridor are counted as a group), which consist of infantrymen and charioteers. This is the main body of the formation.

with retinues of sculptural figures to accompany them on their journeys to the nether world. In earlier dynasties, human beings and animals were ritually sacrificed and entombed together with the deceased. Where was the First Emperor's entourage?

Discovery of Warrior and Horse Figure Pits

After two millennia of silence, the answer was provided by a chance discovery made in March 1974. In the course of digging a well in a field 1.5 kilometers east of the mausoleum, the peasants of the Xiyang Production Team of the Yanzhai Commune unearthed a

Sketch map showing the location of Emperor Qin Shi Huang's mausoleum and the terracotta warrior and horse figure pits.

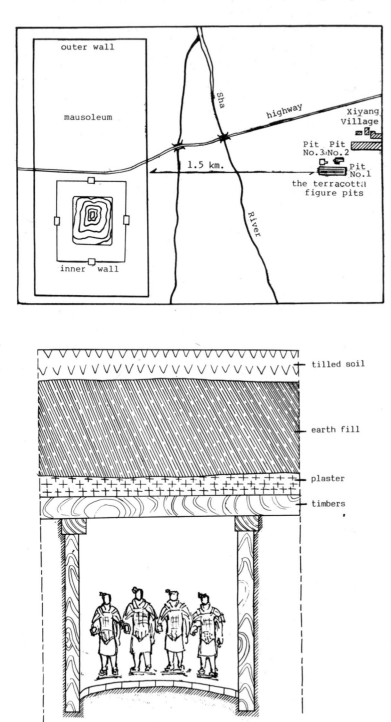

Cross-sectional view of a corridor of Pit No. 1 showing a tentative reconstruction of the earth and wood infrastructure.

KEY — Four-horse Chariot — Warriors

The 2 lines of warriors on the left (northern) and right (southern) sides of the formation are the flanks, which face north and south respectively.

The rear guard to the west consists of 3 rows, 2 facing east with the last facing west.

In the vanguard, except for the 3 armored commanding officers standing at both ends and at the middle of the first row, the warriors all wear coarse tunics, belts, puttees and thonged square-toed sandals. Their hair is put up in a variety of styles and their hands suggest that they carried crossbows and arrows which have since deteriorated.

All the warriors in the main body wear armor. They originally wore swords at their waists and held spears in their hands, and though the wooden parts of these weapons have since disintegrated, the soldiers' fingers are still curled to grasp them. The bronze swords and

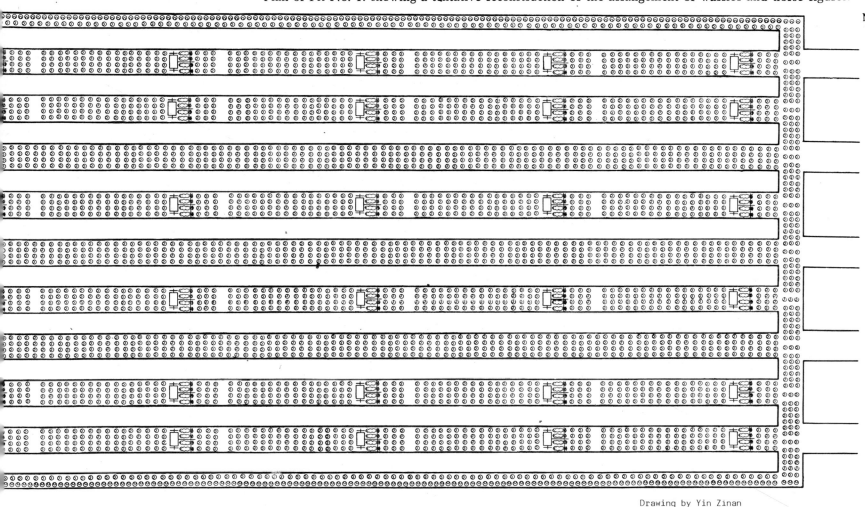

N

Drawing by Yin Zinan

spearheads were found at the figures' feet. These warriors escorted war chariots in the same manner that a modern infantry escorts tanks.

Pit No. 2 and No. 3

Pit No. 2 is located 20 meters north of the east end of Pit No. 1. It is shaped like an inverted "L", stretches 124 meters from east to west, and 98 meters from north to south. It is 5 meters deep and covers an area of 6,000 square meters. In the 18 test excavation sites covering an area of 1,000 square meters, 224 pottery warriors, 96 pottery horses and 11 chariots were found. It is estimated that when the entire pit is excavated, about 1,000 warriors and 80 chariots pulled by over 400 horses will be unearthed.

Pit No. 2 is similar to Pit No. 1 in construction, but it contains an even greater variety of warriors. In addition to infantrymen and charioteers, there are also cavalrymen and archers. The cavalrymen are leading their saddled and bridled mounts. The archers carry either longbows or crossbows. The warriors also include a general holding sword with both hands.

Standing and kneeling archers manned the front lines, while the chariots occupied the right flank and the cavalry stood on the left. In the center was a rectangular formation of interspersed chariots and infantrymen. Additional cavalry brought up the rear.

This mixed military formation corresponds to what in ancient Chinese military lore was known as "Concentric Deployment", a tactic in which each unit could fight either independently or as part of the whole.

Pit No. 3, the smallest of the three, is "U" shaped and lies 25

Sketch of a fully restored Qin Dynasty bow.

The armor of a warrior.

The armor of a general.

The armor of a cavalryman.

The armor of a charioteer.

Sketch of a bronze spearhead.

meters northwest of Pit No. 1. Only 520 square meters in size, it contains 68 warriors and 1 chariot with 4 horses. The figures in Pit No. 3 were arrayed in a defensive rather than combat formation with the soldiers in a circle facing inward. Judging from the dress, gestures and formation of its warriors, Pit No. 3 might be the headquarters commanding warriors of the first two pits.

Significance of Terracotta Army

This great underground army deployed in three separate pits represents the imperial guard of the First Emperor, which during the Emperor's lifetime was stationed to the east of the capital as a defense against a possible revengeful attack by one or more of the conquered six kingdoms. The entire site evokes the military might and spirit which secured Qin the authority to rule a unified China. The orderly and disciplined terracotta formation of Qin's "strong soldiers and sturdy horses" and the excellence of their weapons reflect the importance the First Emperor attached to military affairs.

But the terracotta warriors and horses and their burial accessories offer us much more than military information for they are also an invaluable source of material for the study of Chinese history, politics, economy, culture, art and technology in the period prior to the Western Han Dynasty (206-23 B.C.).

The variety of bronze weapons, for example, still sharp and shining despite 2,000 years underground, demonstrate the advanced level of Qin metallurgy. Chemical analysis has revealed that the swords and arrowheads are primarily bronze and tin with traces of rare metals, and that their surfaces were treated with chromium.

Many years of experimentation must have preceded the achievement of the Qin crossbow with its intricate trigger mechanism. Similar weapons did not appear in Europe until centuries later. Darts propelled from the Qin crossbow could penetrate the armor of Qin's foes, yet the weapon was small enough to be wielded by a mounted archer. Decades later it enabled the Chinese to defeat northern invaders armed with compound bows. The crossbow's darts easily pierced the shields of the well-armed Roman legionnaires in the battle of Sogdiana in 36 B.C.

The burial of pottery figures on a large scale replaced the earlier practice of sacrificing human beings and animals to accompany the deceased in their tombs, thus marking the triumph of the more enlightened ways of the newly emerging feudalism over those of the slave society it was replacing.

Certainly the great variety in dress, physiognomy, facial expressions, hair styles, headgear, armor, weapons, and vehicles of the terracotta warriors affords a wealth of information for the archaeologist and historian, while the artistic aspects alone deserve an elaborate treatment.

Excavation and restoration continues, slowly and painstakingly. Only a few hundred specialists are piecing together the thousands of terracotta warriors and horses still being unearthed.

To better protect and display the excavations of Pit No. 1, a large hangar-like exhibition hall with an area of 16,000 square meters was built and open to the general public in 1979.

With only a fraction of the entire burial retinue exposed to view, observers still find the magnificence and artistry of the First Emperor's underground terracotta army overwhelming. Already it is being hailed as "The Eighth Wonder of the World."

Fu Tianchou

The Art of the Terracotta Warrior and Horse Figures

Some 60 years ago, a man digging a well discovered, besides the water he was seeking, a lifesize terracotta figure of a warrior. But when the entire figure was unearthed, the water in the well suddenly drained away. Because of this, the terracotta warrior was then regarded as something evil and reburied. In March 1974, when the peasants of the Yanzhai Commune in Lintong County near Xi'an were sinking a well some 160 meters south of their village, they uncovered part of a Qin Dynasty (221-206. B.C.) pit of lifesize terracotta warriors and horses. The western extremity of this pit is 1,225 meters from the eastern side of the outer mausoleum wall surrounding the tomb mound of Qin Shi Huang, the First Emperor of the Qin Dynasty.

The discovery attracted the attention of archaeologists, and as test excavations were carried out, the mysteries of the First Emperor's mausoleum complex began to reveal themselves. Several years of exploration have shown that the mausoleum and the adjacent auxiliary burial grounds occupy a square area 7.5 kilometers on each side. The mausoleum itself, with its inner and outer walls enclosing the 47-meter high tumulus in the shape of an inverted bowl, covers an area of 2 square kilometers.

The mausoleum area contains many remains of ancient buildings and burial objects. But it was the unearthing of the underground terracotta army, one of the greatest achaeological finds of the 20th century, which offers the most graphic evidence of the might and majesty of Qin Shi Huang, the first unifier of China, and is of great cultural and artistic value.

Reassessing the Realistic Tradition in Chinese Art

In the past, very little was known about the sculptural art of the Qin Dynasty. As one of the largest group sculptures in the world and an outstanding example of realistic art, the terracotta army will enable artists and scholars to reassess the realistic tradition in ancient Chinese art.

A semi-circular, decorative eaves-tile of the Warring States Period.

The designs engraved on many pre-Qin jade, stone, pottery and bronze relics dating from as early as the Xia Dynasty (c. 21th — 16th century B.C.) are depictions of animals, plants or mythological figures. Such artifacts have great significance for an understanding of the thought and culture of early China. Yet very few works of sculpture directly reflecting the daily life and material civilization of this early period in Chinese history have been discovered. Thus the huge array of true-to-life pottery warriors and horses found near Qin Shi Huang's tomb is an unprecedented discovery which throws much light on the development of realistic art in ancient China.

Variety in the Warriors' Faces and Expressions

A common defect in group sculpture is monotony. The Qin

11

The ten basic head shapes of Qin Shi Huang's terracotta warrior figures and the Chinese characters that they resemble:

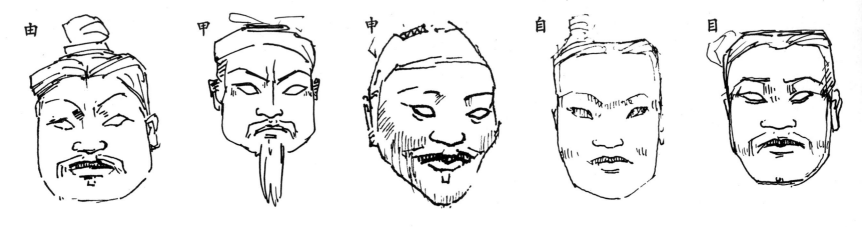

terracotta figures are, however, an exception to this. In the rectangular formation of Pit No. 1 which contains mainly infantrymen, the warriors' faces and expressions are in no way identical; and though they all stand erect in an attentive manner, each soldier has his own particular features. Some have tightly closed lips and forward-staring round eyes, and manifest a distinct character of steadiness, bravity and fortitude. Others show vigor, resourcefulness and confidence. Still others evince a sense of volition and thoughtfulness, suggesting the wisdom and talent of veteran warriors who have fought numerous battles. Judging from the range of ages, some are moustached soldiers long tested in battle, some are sturdy and valiant middle-aged fighters, while others look like young recruits. As for their status in the army, some appear to be junior officers rising from the ranks, while others are cautious and obedient young soldiers.

These varied and lively images are neither the product of a subjective imagination nor mechanical copies of individual people. Rather they are the rendering by induction and refinement of a countless number of images taken from real life, and hence works of art displaying characteristics even more distinctive than their living models. Some experts classify the unearthed warrior figures into as many as 30 types. If the shapes of the faces are compared to Chinese written characters, they can be divided into the following ten categories:

(you) (jìa) (shen) (zì) (mu) (tian) (guo) (rì) (yong) (Feng)
由　甲　申　自　目　田　国　日　用　凤

A "由" face is smaller at the top and widens towards the bottom; that is, the cheekbones are broader than the forehead. This face belongs to mighty warriors. The "甲" face is the exact opposite, with a broad forehead, small cheekbones, thin lips and a pointed chin. Such faces are numerous among the vanguard and represent an alert and rewourceful personality. "申" faces are pointed at both the top and

bottom, and are relatively few in number. Directly opposite is the square "田" face, with large, thick-browed eyes, thick lips and wide noses, a type which gives an impression of honesty and sincerity.

"The "国" face is similar to the "田" face, though somewhat longer and more elegant. It portrays an honest, straightforward character with inner refinement—a keen mind behind a coarse exterior. The serious and intelligent "凤" face is similar to the "国" face but wears a moustache, while "日" and "目" faces are long and delicate.

The different shapes and features of the faces give each warrior personality of his own. The corners of the eyes, for example, may slant upwards or droop downwards, and the eyes themselves may be half-closed or wide open. Eye shapes include the so-called "apricot", "monkey", "intoxicated" and "phoenix" varieties. Eyebrows vary in thickness and angle of inclination, and include such types as "willow leaf," "silk worm" and "sword". Noses, lips and ears also come in a wide variety of shapes.

As for the figures themselves, the close coordination of the head and body, both aesthetically important and technically difficult, is carried out with great skill. The proportions of the heads and bodies are well balanced, the figures measuring 7.5-8 times the height of the head. The hefty torso and sturdy legs give the impression that the warriors are strong and stalwart. It is interesting to note that the heights of the terracotta warriors in the three excavated pits range between 1.75 and 1.98 meters, somewhat taller than the average height in Qin times. A principle commonly applied in sculpture is that sculptured figures must be larger than life if they are to represent lifesize figures in an impressive way. This principle was clearly understood and applied by the anonymous Chinese artists of more than 2,000 years ago. In addition, the "law of harmonious form", often overlooked by some sculptors, yet was applied with great ease and mastery by the artists who produced the Qin terracotta army.

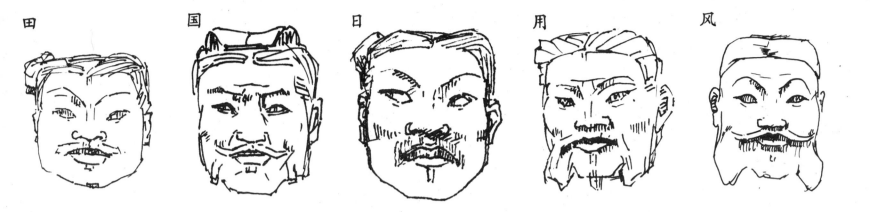

田 国 日 用 风

Skilful Rendering of Warriors' Dress

In their rendering of warriors' dress, the creators of the terrocotta army also showed a great familarity with their subject matter. The terracotta figures inherit the pre-Qin tradition of rejecting smaller details such as garment folds while emphasizing overall effects, and show a tendency towards the use of geometric forms. For example, the tunic of certain figures flares out from the waist down to form a trapezoidal step-like bulge. But the sculptors were distinctively realistic in their basic approach. The highly detailed platearmor tunics worn by the warriors with their waist sections ingeniously designed to enable the wearer to bend over, reveal that the artisans who created these figures were well versed in both the form and function of their subject matter. The battle dress of each warrior can be appreciated as integrated works of art in their own right, and it should be noted that in each case they fit their wearers perfectly.

Finely Bred Horses

great historical and artistic interest. Sun Bole, the author of a *Guide to Horse Selection (Xiang Ma Jing),* lived in the state of Qin at the time of Qin Mu Gong (?-621 B.C.). Sun and his contemporary Jiu Fanggao, the founder of a second school of horse connoisseurship, laid down the standards for fine horses several centuries before the time of Qin Shi Huang.

The discovery of the terracotta horses in the underground army of Qin Shi Huang confirms that these standards had been handed down through Qin Times. According to archaeologists, these terracotta figures are recreations of a large vigorous breed of the Qin horses, that could gallop for long distances at high speed. The height of the horses' heads averages 1.54 meters and that of the shoulders 1.30 meters. The average length of the body is 2 meters. The detailed characteristics of the horses conform with the rather picturesque requirements of the *Guide to Horse Selection*: pillar-like forelegs, bow-like hind legs, high hoofs, slim ankles, wide notrils, broad mouths, short and small ears resembling bamboo shoots and heads resembling rabbits' heads. Their full noses indicate powerful lungs, which make it possible for the horses to cover long distances.

The horses' saddles are covered with rows of nailheads and decorated with tassels. They were originally painted red, white, brown and blue and designed as if they were made out of leather. The quality of the workmanship in the saddles is of an extremely high standard. That the horses in the cavalry have no stirrups is further evidence of the skilled horsemanship of the soldiers in Qin Shi Huang's army.

Motion Within Stillness

Looking down from the observation platform in the exhibition hall at the vast underground army of Qin Shi Huang, one can almost hear the rhythmic beat of marching soldiers and the neighing of war horses. How do these motionless terracotta figures manage to make the viewer feel that he is witnessing an army in action? Like the stone men and beasts that have guarded Chinese imperial tombs through the ages, the Qin Dynasty sculptures of warriors and horses are motionless figures in a given number of postures repeated innumerable times. Generally speaking, group sculpture of this type tends to be tedious, but the Qin sculptures ingeniously utilize repetition and stillness to create a sense of "motion within stillness" and give the army, standing in full readiness for combat, an impressive and dignified air.

Archaeologists suggest that these warrior and horse figures

13

represent either the Qin army awaiting orders for battle or imperial guards protecting the First Emperor. They also explain that right up until his death, Emperor Qin Shi Huang constantly worried about a possible revolt rising against him in the six eastern kingdoms which he had conquered to form his empire, and for this reason the underground army faces east. Although these suppositions differ in some respects, they agree on two points. First, as it stands, the army is not actively engaged in battle. And second, the army appears to be alert to the presence of the enemy and seems prepared for an imminent battle. That is to say, the still postures strongly suggest movement, and the concept of "motion within stillness" is fully reflected in the figures.

The best way to appreciate this "motion within stillness" is to walk among the sculptures themselves. As large-scale group sculpture, the Qin terracotta army differs from other group sculpture in terms of the ideal angle from which the composition should be viewed. It also differs from sculpture erected in an open space which must be walked around to be viewed properly, and from cliff carvings which can only be viewed from one side and in one direction. The relationship between the viewer and the terracotta army is similar to that between the viewer and traditional Chinese temples and palaces, which are composed of a series of courtyards. That is to say, in order to appreciate the architecture of the buildings, the viewer must enter the courtyards, placing himself among the structures themselves, and in the case of the Qin terracotta army, the viewer must walk among the figures. European cathedrals thrust boldly upwards to emphasize their height and mass, while the Imperial Palace (*Gugong*) in Beijing appears almost ordinary when viewed from the outside. But as soon as one steps within the Palace walls, the lofty magnificence of the structures is immediately evident. The Qin terracotta army and traditional Chinese architecture thus have many similarities in the structure of their overall layout.

How the Pottery Figures Were Made

The Qin figures are the largest terracotta sculptures unearthed in China to date. Standing at heights of between 1.75 and 1.98 meters, the figures would have shrunk approximately 18 per cent in firing, which means that unfired they would have stood over 2.2 meters tall on the average. Even today, sculptures of this size are difficult to execute and require a suportive framework of either wood or metal to prevent them from collapsing or becoming distorted during the firing process. How then were these thousands of human and animal figures created?

Preliminary research indicates that these sculptures were made by a process combining the use of molds and hand modeling. The heads were made separately from several dozen different molds, each mold being used to press out large numbers of semi-finished heads which

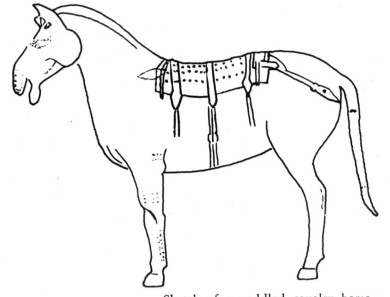

Sketch of a saddled cavalry horse from Pit No. 2.

were then finished off by hand. In this way, heads produced from the same mold would bear little or no resemblance to each other. Further processing at a later stage gave the heads greater individuality by varying the flesh, facial features, hair and beards. The heads were molded without ears, which were pressed out from separated molds and affixed later. Moustaches were also prefabricated, and hair, headgears, lips and eyes also show traces of having been added separately to the basic molded head.

In terms of weight distribution, large-scale sculptures are like buildings — if the center of gravity is not correctly positioned it will collapse. The Qin warrior figures are naturally topheavy, and had they been constructed of clay of a uniform thickness throughout, their center of gravity would have been extremely difficult to place properly. In addition, the figures' slender ankles would appear to lack the strength to support a heavy weight. The Qin sculptors sucessfully solved both of these problems.

The Qin figures were modeled from a fine textured gray clay which when fired produced a delicate finish very pleasing to the eye. We know that the figures were painted in colors after firing, although only traces of this paint remain adhering to the unearthed figures.

Evidence of Pre-Han Realistic Sculpture

In the past, some art historians believed that before the Western

Han Dynasty (206-23 B.C.) China's sculptural art consisted only of decorative elements on the surface of various utensils or small carved objects, but no large-scale realistic sculpture. The simple lifelike stone sculptures found at the tomb of the Western Han general Huo Qubing (140-117 B.C.), which were roughly carved by closely following the original shape of the stone, were believed to be the earliest example of realistic sculpture in China. The excavation of the Qin terracotta army, however, serves to revise this notion by providing us with concrete historical evidence that large-scale, realistic group sculpture was produced in the pre-Han period. This discovery also suggests that realistic sculpture of a high standard existed in pre-Qin times but failed to survive because it was made of perishable materials. The decorative designs on relics dating from the Xia (c. 21th-16th century B.C.), Shang (c. 16th century-1066 B.C.) and Zhou dynasties are mostly on bronzes, which easily survive the centuries, while large-scale realistic sculpture executed in clay or wood became disintegrated later. Not until the Han (206 B.C.-220 A.D.), Southern and Northern (420-581), and Tang (618-907) dynasties was stone widely employed in largescale sculpture, and thus much of the early sculpture which has come down to us dates from this period.

From all indications it would appear that two trends-the realistic and the decorative — existed side by side in Chinese sculptural art during the early period, though in different eras the emphasis shifted between the two. The discovery of the Qin terracotta figures provides important evidence to support this theory.

A Comparison with Ancient Greek Sculpture

Lastly, it is also interesting to note that there are certain parallels between the development of ancient Chinese sculptural art and that of ancient sculptural art in the West, and yet each tradition displayed its own distinctive characteristics. Both the ancient Greeks and their Chinese contemporaries explained that unpredictable natural phenomena and the enigmatic workings of "fate" were controlled by the gods or spirits, which they perceived as exalted and omnipotent.

Before the introduction of Buddhism into China during the Eastern Han Dynasty (25-220), these gods were frequently depicted in Chinese art in the form of animal figures, while the ancient Greeks carved their stone gods in human form. For example, Nüwa, the mythological female creator of the human race, was depicted on early Han bricks with the upper half of her body in the form of a beautiful woman and the lower half as a snake, while the protective deities of the four compass directions were depicted as dragon, tiger, red bird, and combined snake and turtle. The Greek sculpture of the same period, however, portrayed the gods as naked men and women, thus testifying

Sketch of a stone figures typical of those placed before Chinese imperial tombs.

to an entirely different cultural and artistic tradition.

Thus while the Qin terracotta warriors and Greek stone gods similarly take the form of the human beings, Chinese and Greek artists approached the function of human figure sculpture in their own unique ways. The Greek gods, a product of the mythological imagination, were created to protect and shed their blessings upon, living men. The Qin terracotta warriors were modeled after the living army which fought to unify China under the command of Qin Shi Huang, and are sculptures taken directly from life, while the Greek sculptures were created in pursuit of a divine ideal. The ancient Chinese, believing in life after death and in serving the dead and living alike, evolved the practice of extremely lavish burials. Following this logic, the Qin terracotta army was conceived of as still serving under the command of the deceased First Emperor. Greek sculpture was the perfect expression of the religion and philosophy of Greek civilization; the Qin terracotta army likewise provides firsthand information about the weapons, outfits and organizations of the contemporary army.

It is expected that future excavations in the area of Qin Shi Huang's mausoleum will provide us with an increasingly richer store of material for the study of ancient Chinese art and its role in the development of world culture.

Photographs

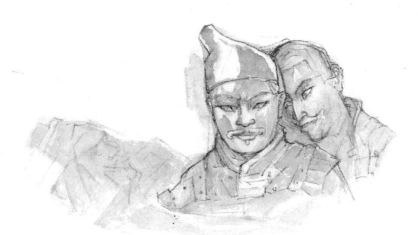

1. The Mausoleum of Emperor Qin Shi Huang and the Excavation of the Terracotta Warrior and Horse Figure Pits

The mausoleum of Qin Shi Huang, the First Emperor of the Qin dynasty, is located in imposing surroundings five kilometers to the east of Lintong County in Shaanxi Province, with Lishan Mountain to its south and the Wei River to its north. It is surrounded by orchards of fragrant apricot trees. The underground palace, built more than 2,000 years ago, has not yet been excavated. But judging from the results of test drillings and excavations, the mausoleum and the accompanying burial grounds occupy an area of 56 square kilometers. The mausoleum with its outer and inner walls surrounding the tomb mound was built with an eastward orientation, and covers an area of two square kilometers. The tomb mound itself, shaped like an inverted bowl, towers 76 meters over the southern section of the inner wall. It is said that the tomb was originally surrounded by huge stone animals, but to date these have not been found.

In the neighborhood of Xiyang Village, 1.5 kilometers east of the mausoleum, are the pits containing the terracotta warrior and horse figures. So far four such pits have been discovered. Pit No. 1 contains mainly infantrymen along with a number of charioteers. Pit No. 2 contains cavalrymen and armored kneeling archers. In Pit No. 3, the presence of commanding officers, their aides and bodyguards suggests that this was presumably the command headquarters. No warrior or horse figures were found in Pit No. 4. Perhaps a rebellious peasant army approaching Xianyang, the Qin capital, forced the construction of the mausoleum to a halt.

View of the mausoleum of Emperor Qin Shi Huang.
Photo by Weng Naiqiang

The heaped earth mound covering the tomb of Qin Shi Huang rises up behind an apricot orchard. On the right, to the east of the tomb mound, is the Museum of Qin Shi Huang's Terracotta Warrior and Horse Figures. Bronze warrior and horse figures were excavated from a pit 17 meters to the west of the tomb mound.

Photo by Weng Naiqiang

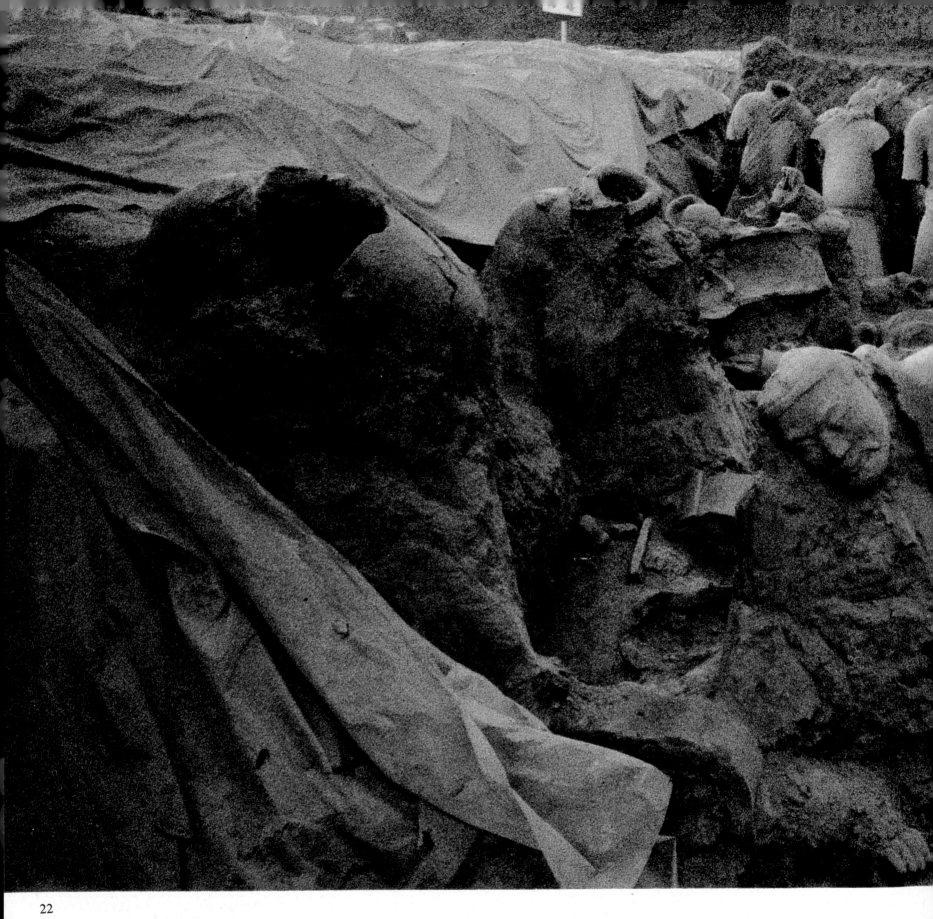

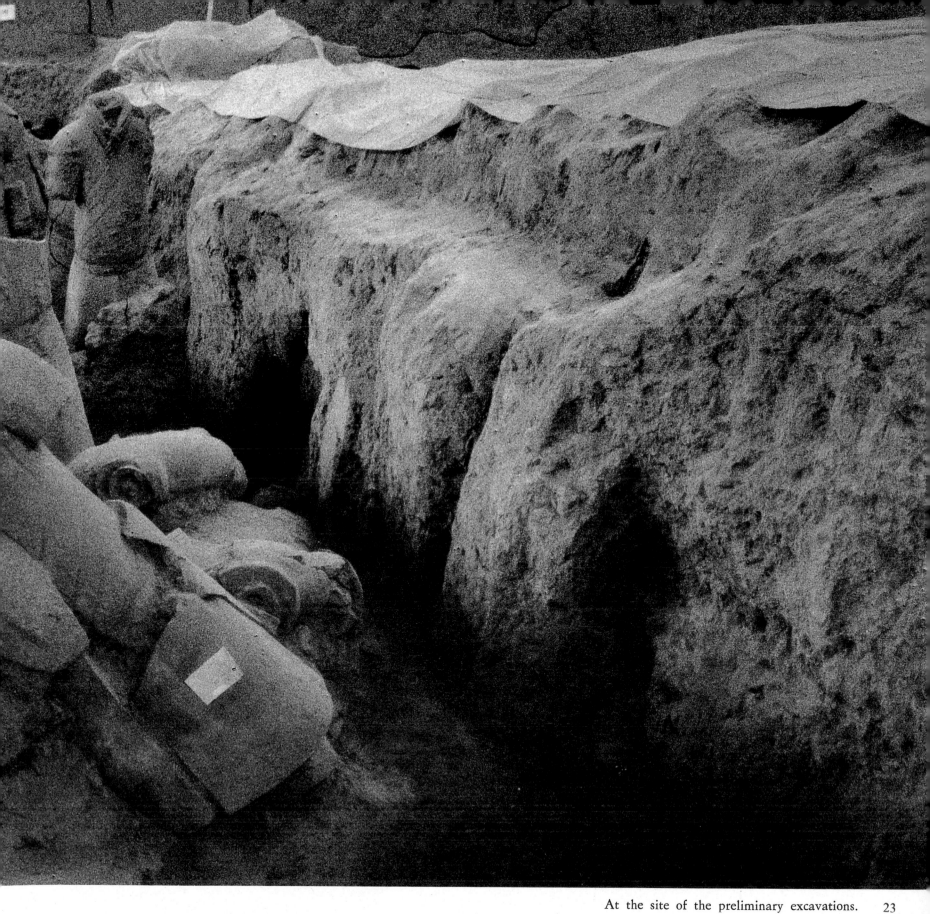

At the site of the preliminary excavations. 23

Photo by Wang Jingren

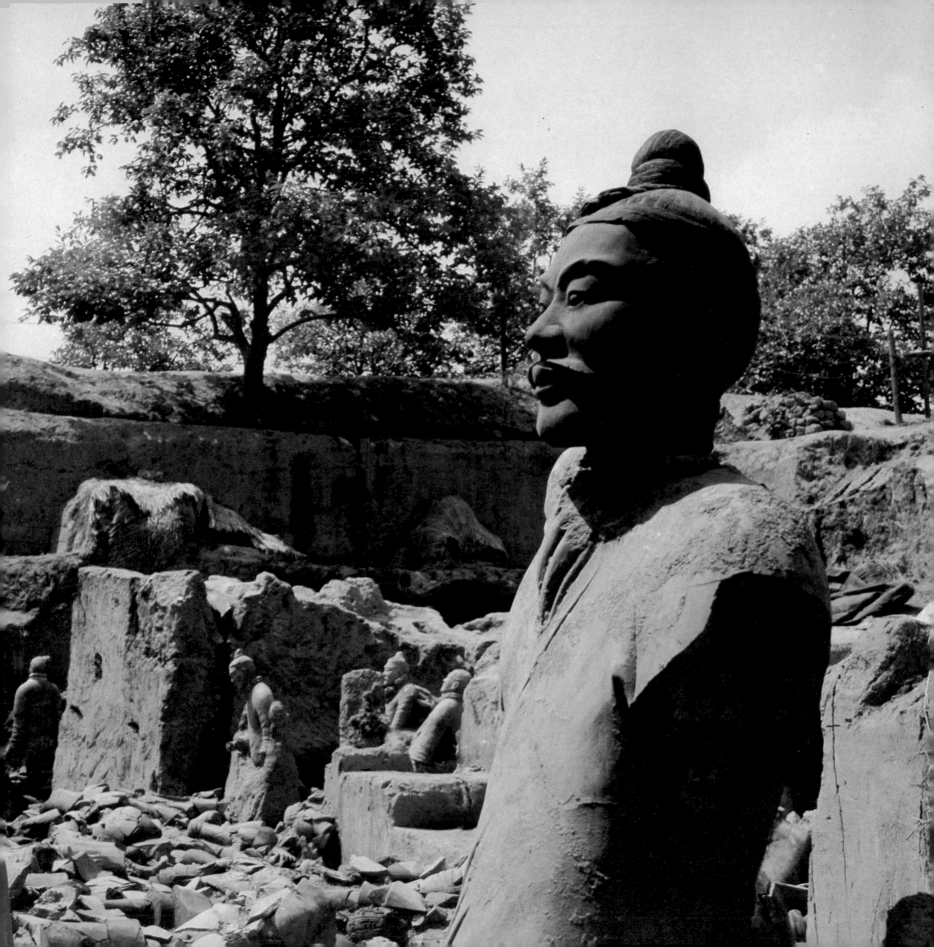

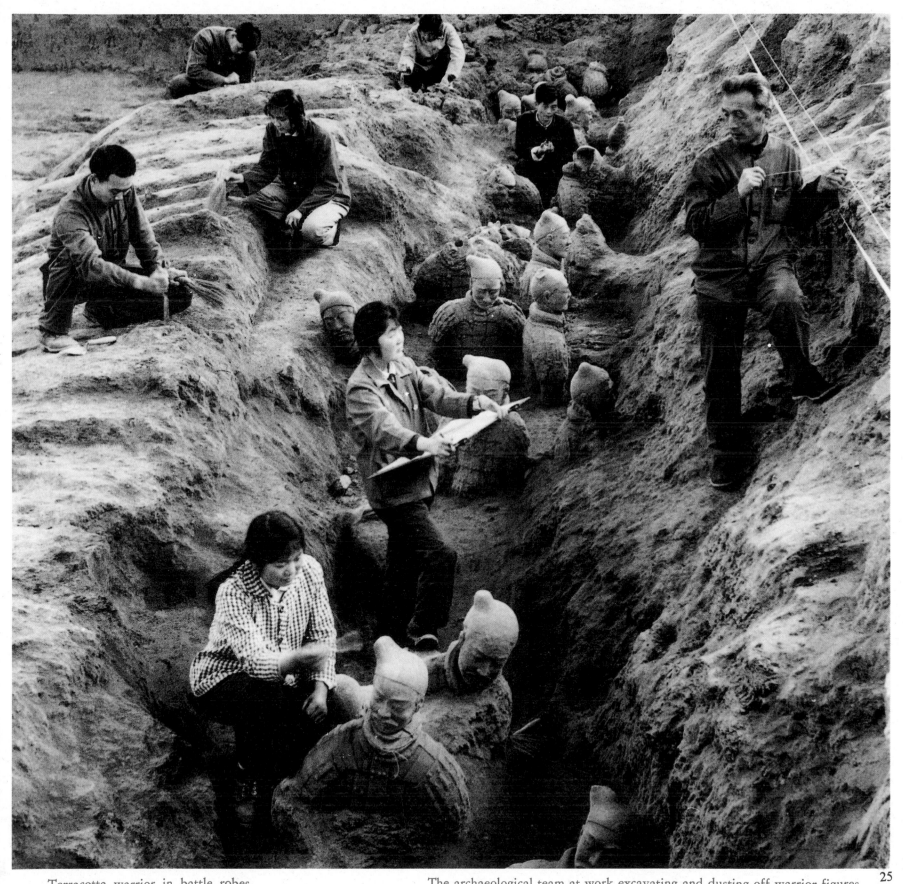

Terracotta warrior in battle robes.

Photo by Wang Lu

The archaeological team at work excavating and dusting off warrior figures inside the pit.

Photo by courtesy of Xinhua News Agency

25

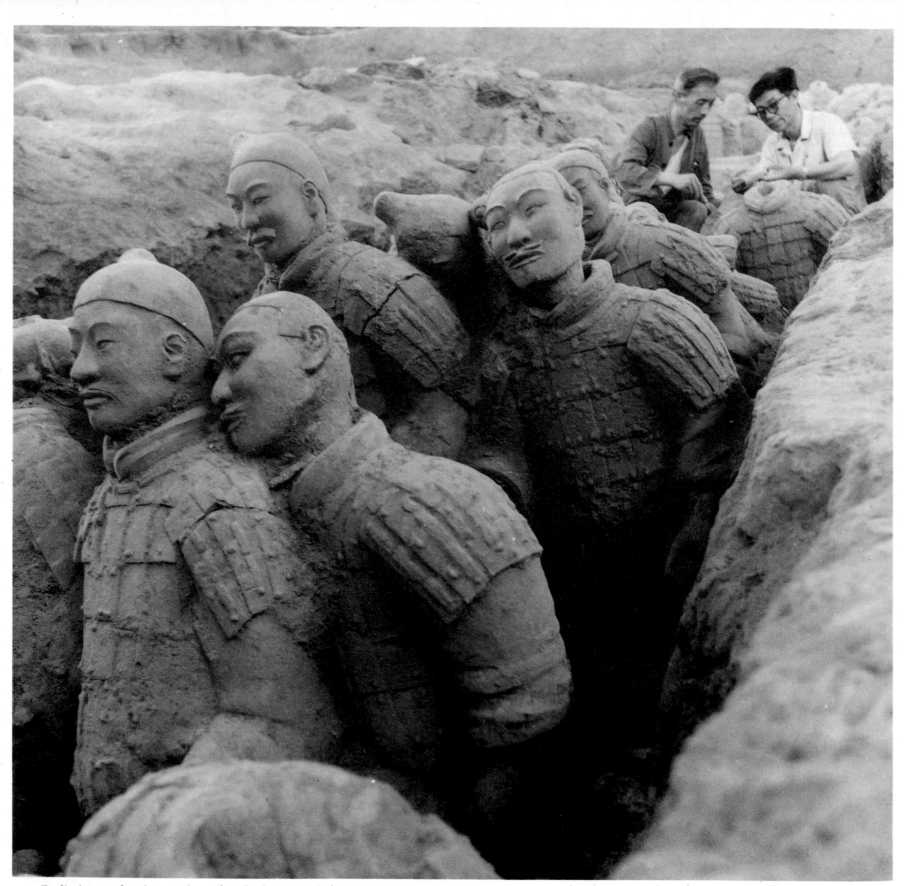

Preliminary cleaning-up has already been carried out on these armor-clad warrior figures. Photo by Wang Tianyu

At the excavation site, a group of terracotta figures await restoration. Photo by Wang Tianyu

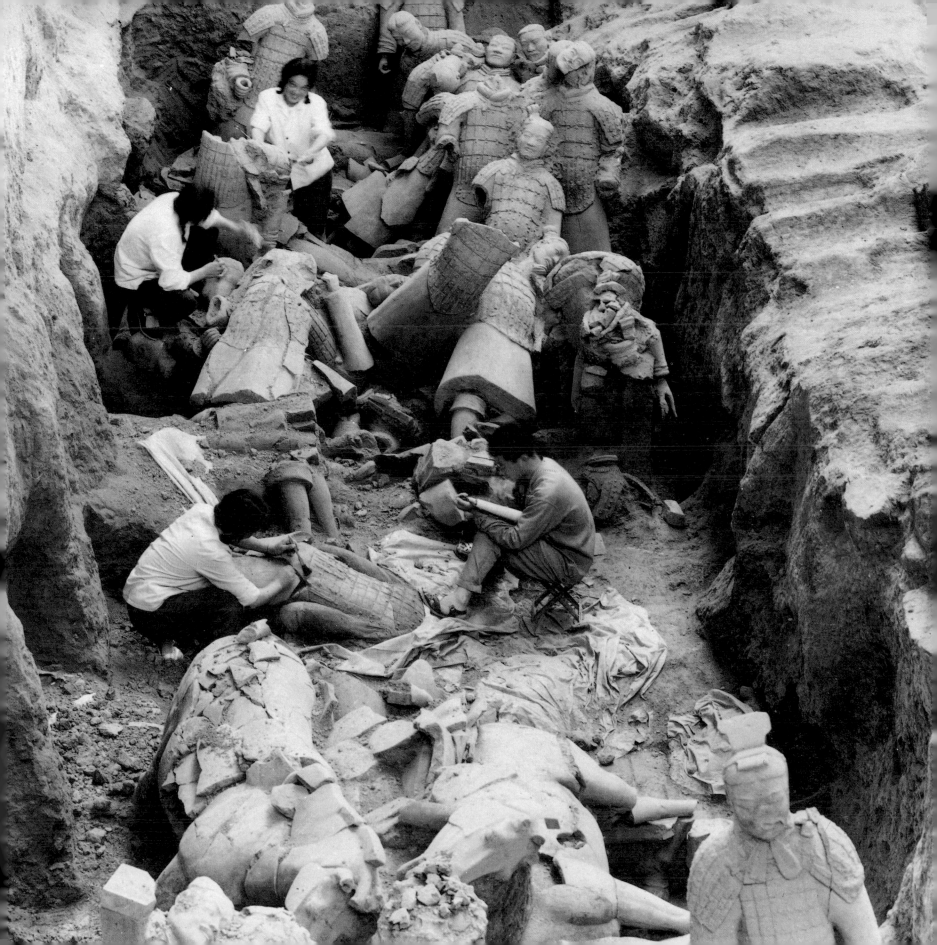

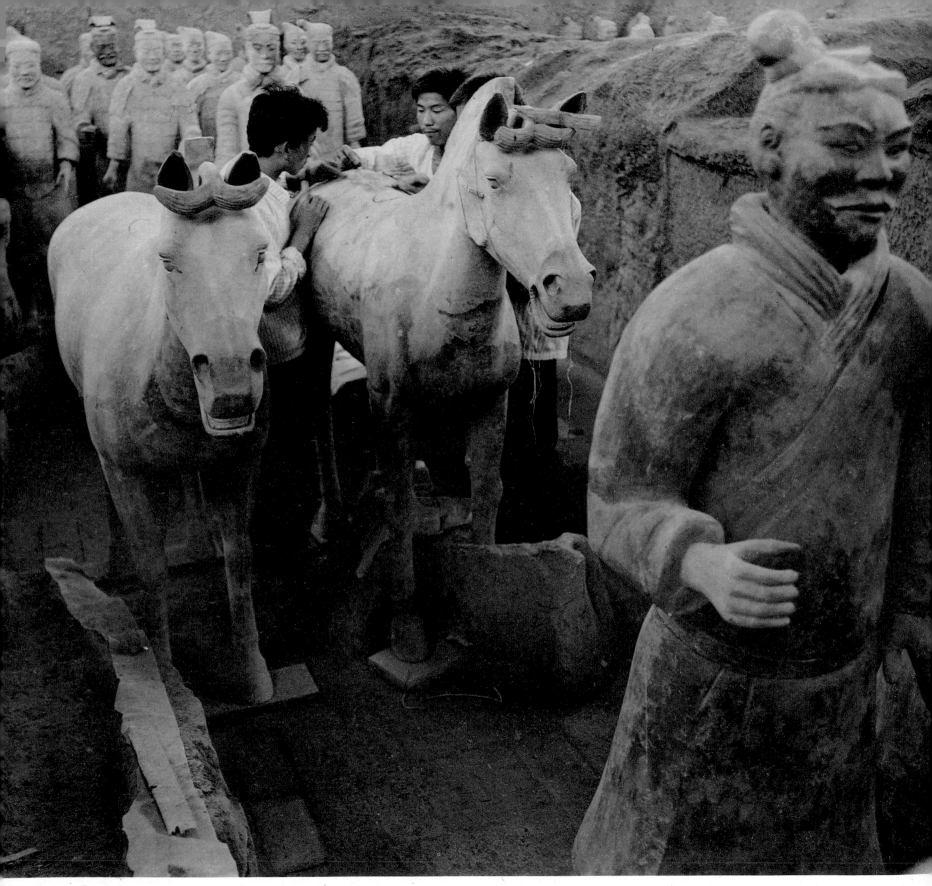

Fully restored horses and armor-clad warriors.
Photo by Wang Tianyu

2. The Exhibition Hall and Pit No. 1

The exhibition hall of the Museum of Qin Shi Huang's Terracotta Warrior and Horse Figures built over Pit No. 1 is a pillarless steel structure 230 meters long with an arched roof that spans 70 meters. The roof is made up largely of glass panels, thus allowing natural daylight to illuminate the terracotta army. To date, more than 1,000 terracotta warriors have been unearthed from the east end of the pit, where the main work of excavation has been carried out. The warriors have an average height of 1.8 meters. In addition, 24 terracotta horses harnessed to chariots and 7,000 pieces of bronze weapons, gold, bronze and stone ornaments have been found along with traces of the framework of earth and wood which once covered the pit.

Test excavations at the western and middle sections of the pit have revealed more warrior figures, from which it can be deduced that the entire pit is filled with orderly ranks of soldiers arrayed in a rectangular formation. Judging from the density of the figures already excavated in the east end of th pit, the entire pit contains some 6,000 terracotta warrior and horse figures.

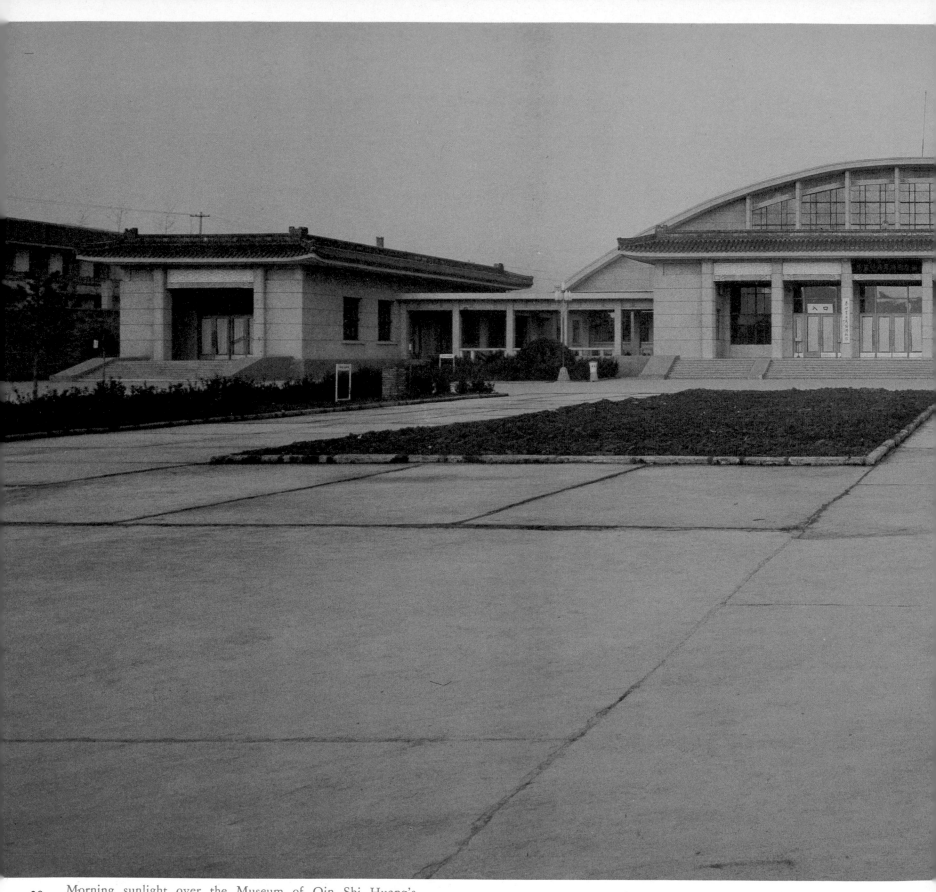

30 Morning sunlight over the Museum of Qin Shi Huang's
Terracotta Warrior and Horse Figures. Photo by Weng Naiqiang

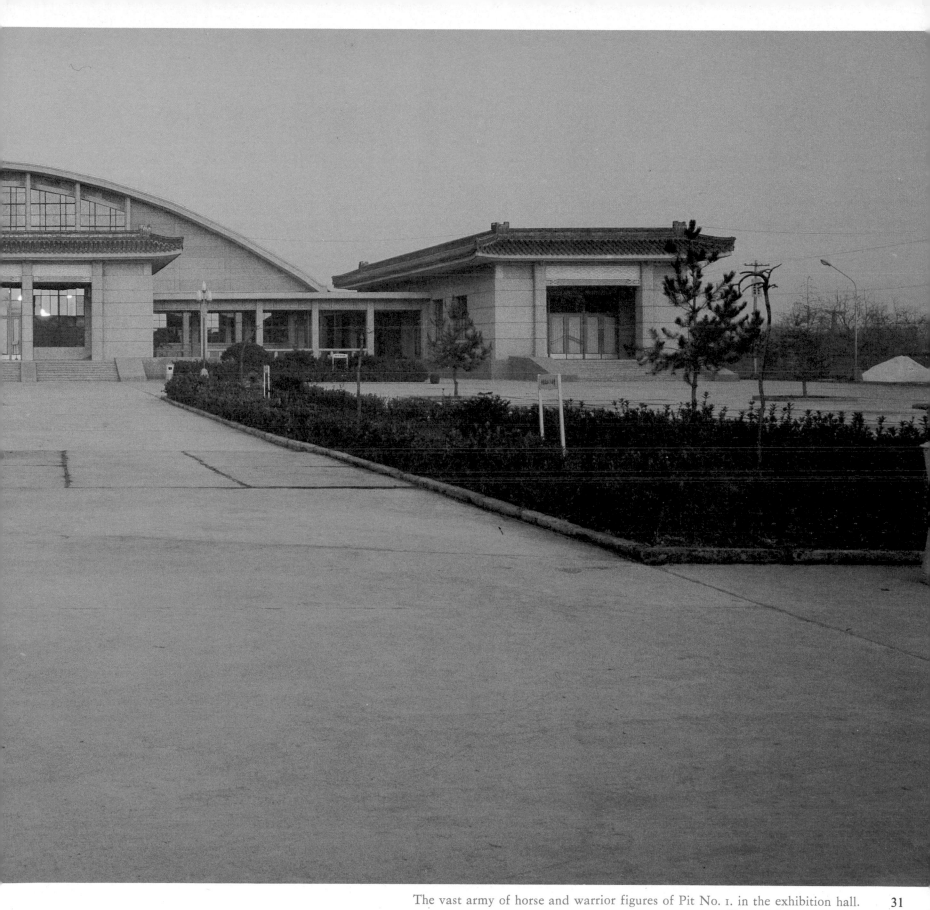

The vast army of horse and warrior figures of Pit No. 1. in the exhibition hall. 31
Photo by Weng Naiqiang

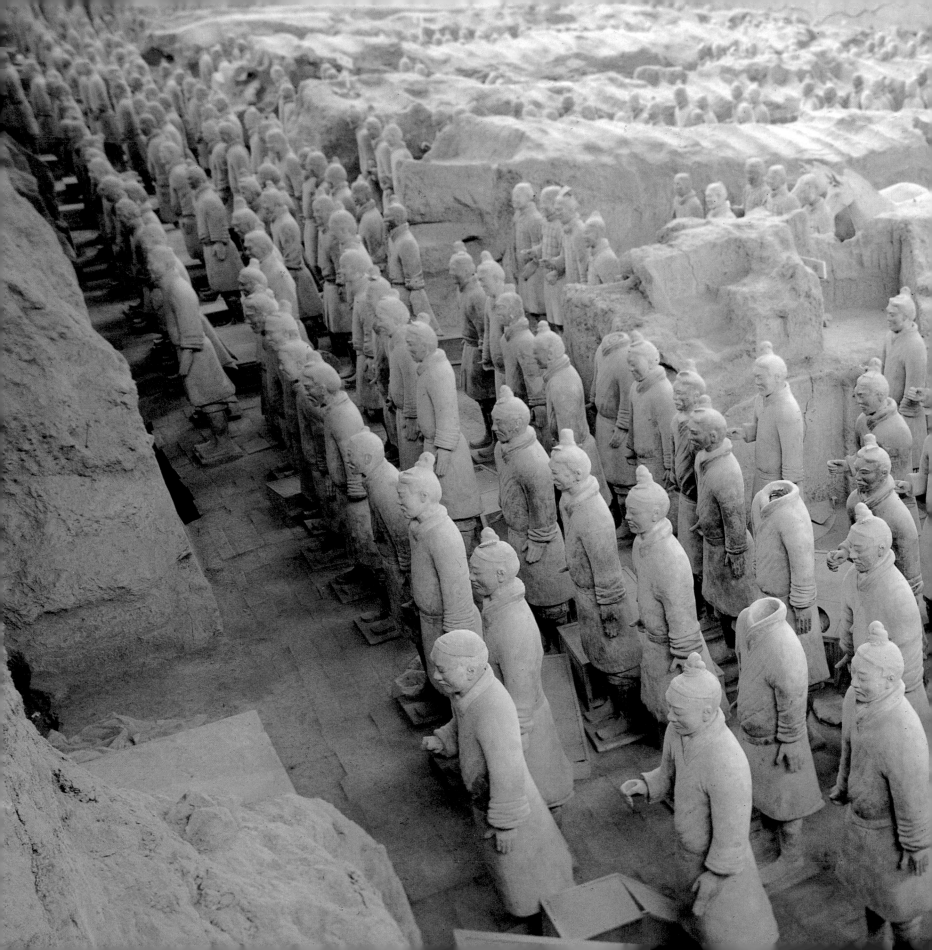

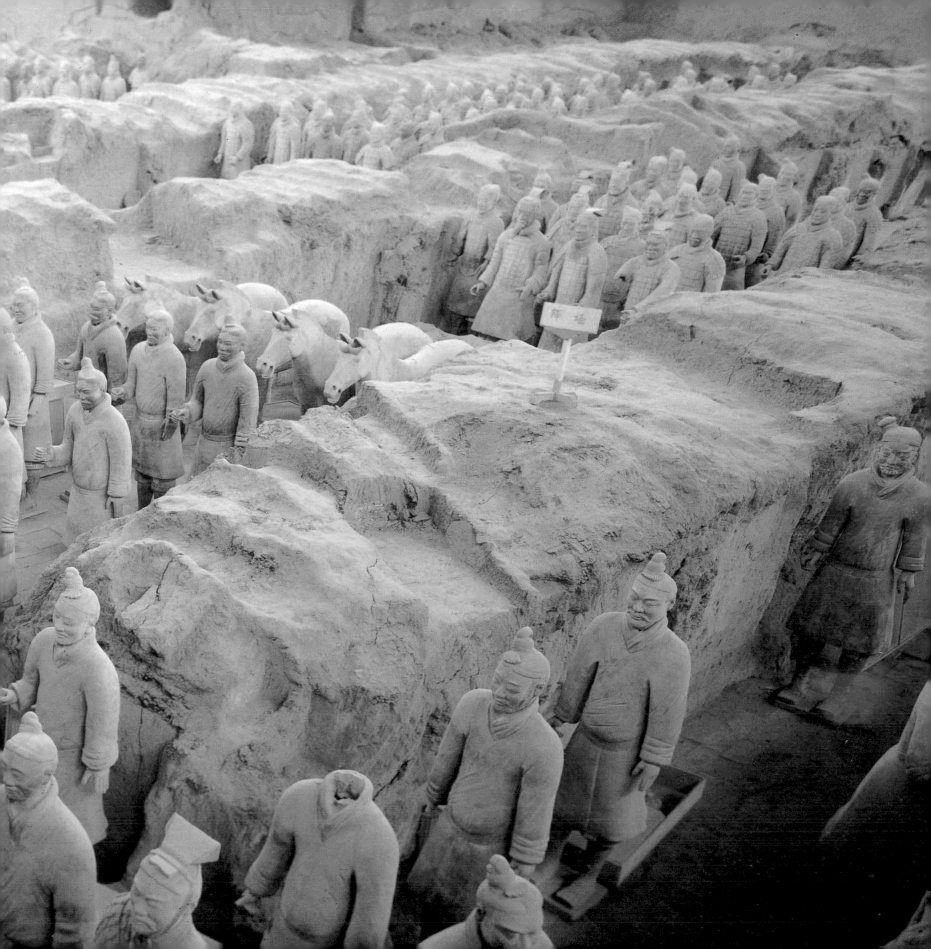

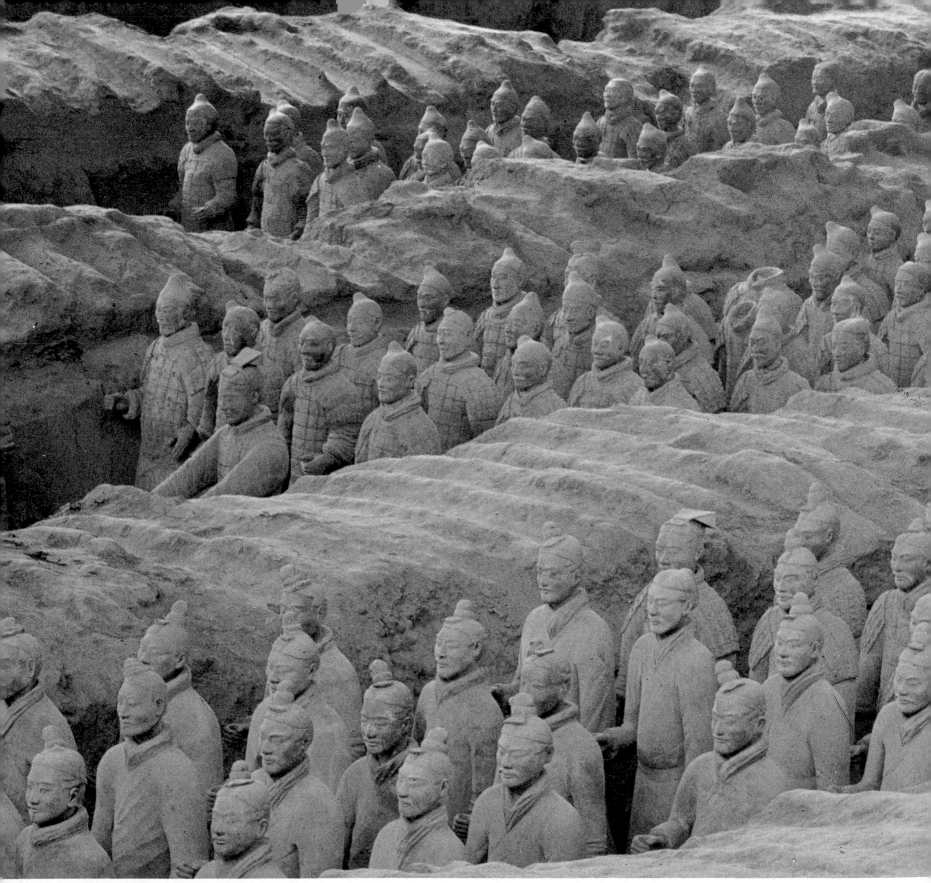

34 A corner of the exhibition hall.
Photo by Weng Naiqiang

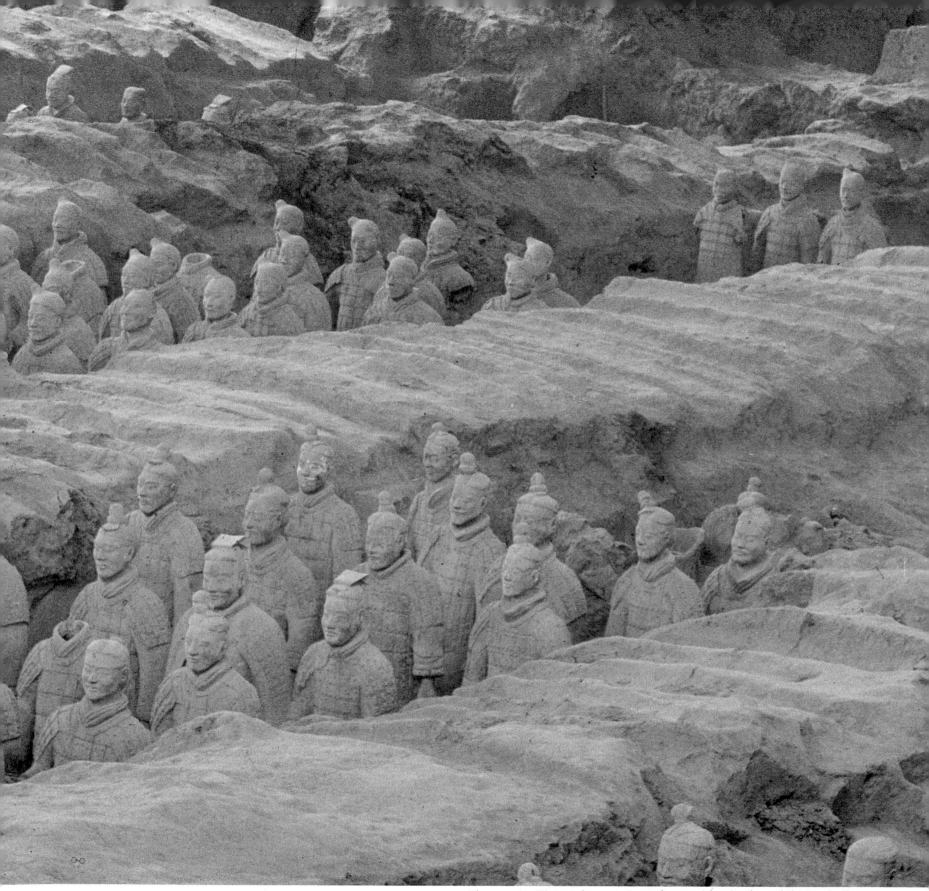

Troops awaiting orders — view of a corridor in the exhibition hall.

Photo by Weng Naiqiang

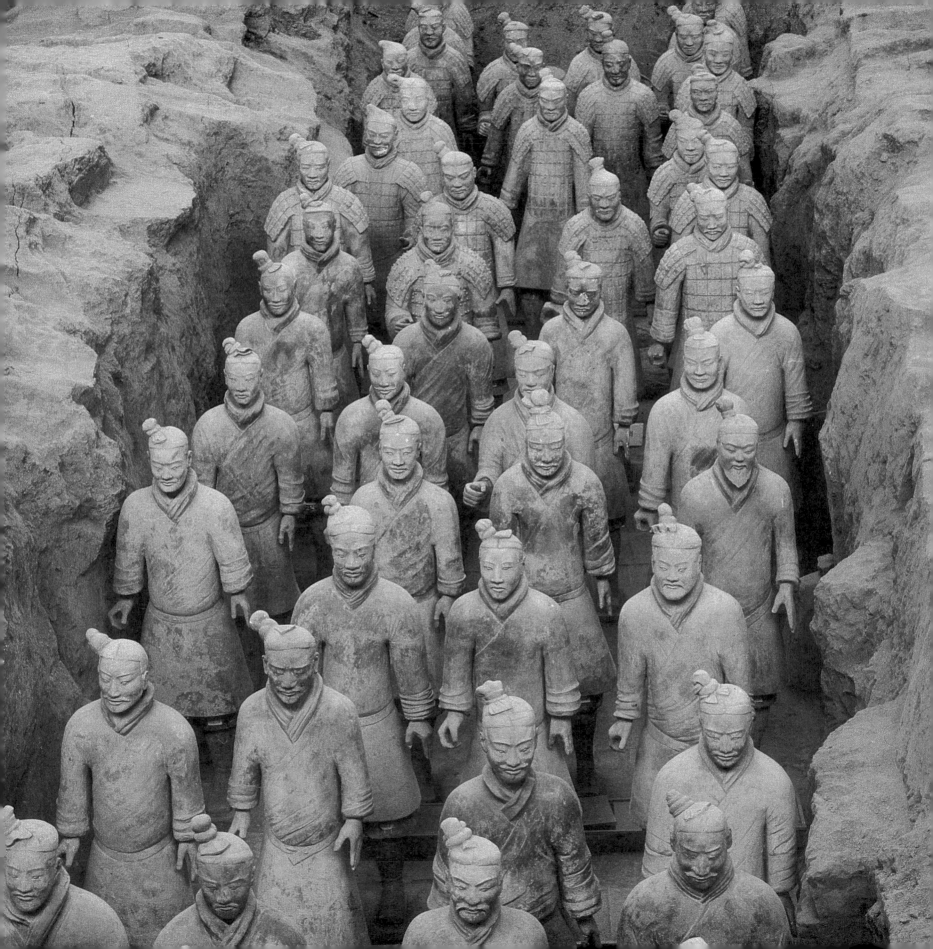

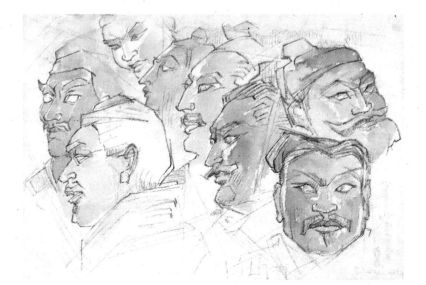

3. Terracotta Warriors

Apart from a small number of horses, the terracotta figures in the pits are mostly life-size terracotta warriors representing the officers and men of Qin Shi Huang's army. The warriors can be divided into two groups, those with and those without armor. Those without armour are deployed mainly in the vanguard section of Pit No. 1, where 207 are not wearing armor and only three are. The warriors on the northern and southern flanks of Pit No. 1 also wear no armor, while the greater majority of the warriors in the main body of the formation are in armor.

The armored warriors include infantrymen, cavalrymen and charioteers, and, in terms of rank, include generals, officers and ordinary soldiers. The armored warriors wear headgear, while the bareheaded have their hair bound up in a variety of styles. These differences may be attributed to the personal taste of individual soldiers or to the ranks or services to which they belong. Though neither of these explanations can be substantiated by written records, the latter seems more plausible than the first.

The armor worn by the warriors comes in a variety of types which indicate the wearer's rank and function. In general, those in high positions wear armor with small and closely-spaced plates while common soldiers' armor has bigger and coarser plates. The plate mail worn by calvalrymen is generally shorter, allowing greater freedom of movement. For the charioteers who are easy targets of attack, and whose position allows for little freedom of movement, the armor covers the shoulders and the greater length of the body. The variety of armor provides valuable data for the study of Qin army organization.

An examination of the faces of the terracotta warriors reveals that the Qin army was a multi-nationality force, composed mostly of Han men from the northwest regions of present-day Shaanxi and Gansu Provinces. Some display the facial features of men from Shu (present-day Sichuan Provinces) as well as minority nationalities. The wide range of expressions they bear furnishes further valuable material for the study of sculptual art in ancient China.

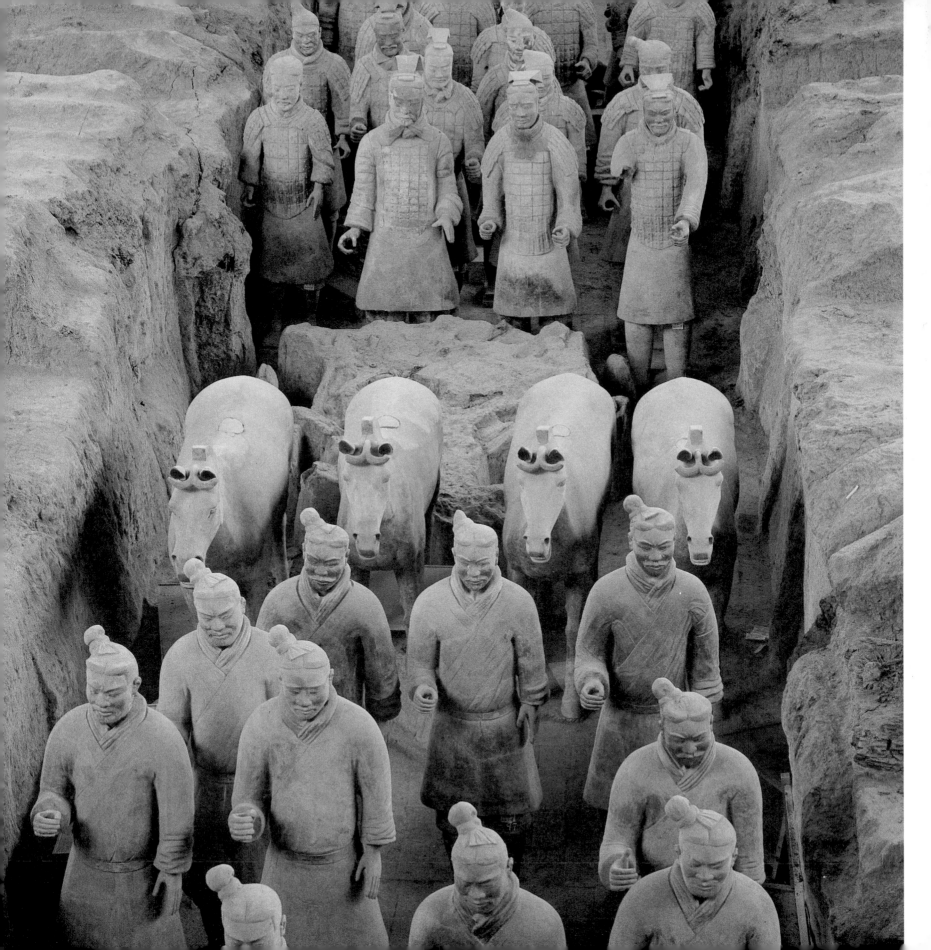

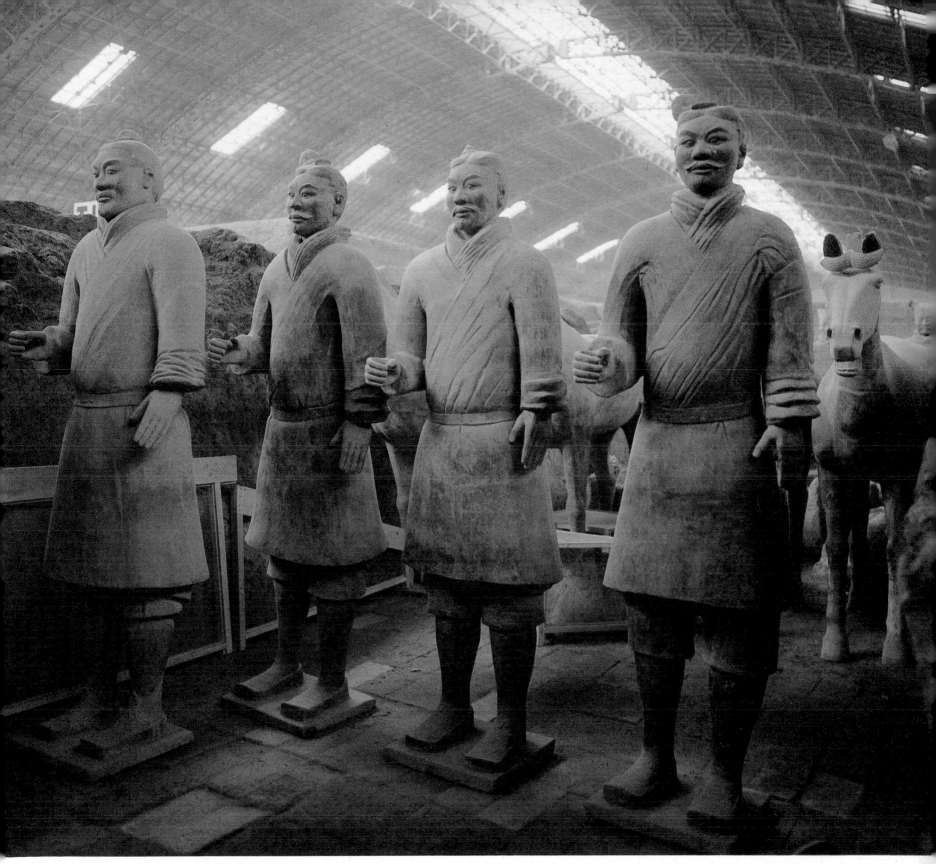

Robed warriors in the foreground lead a four-horse
chariot and a column of armor-clad warriors.

Photo by Weng Naiqiang

Four robed warriors.

Photo by Wang Jingren

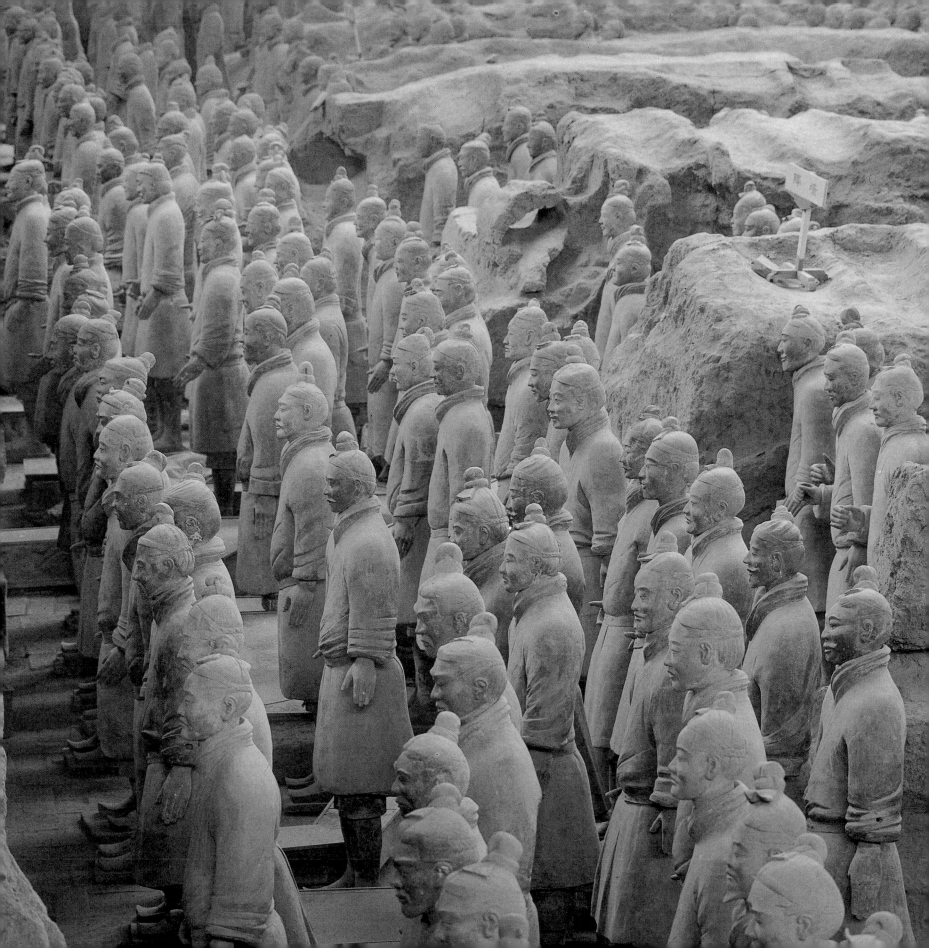

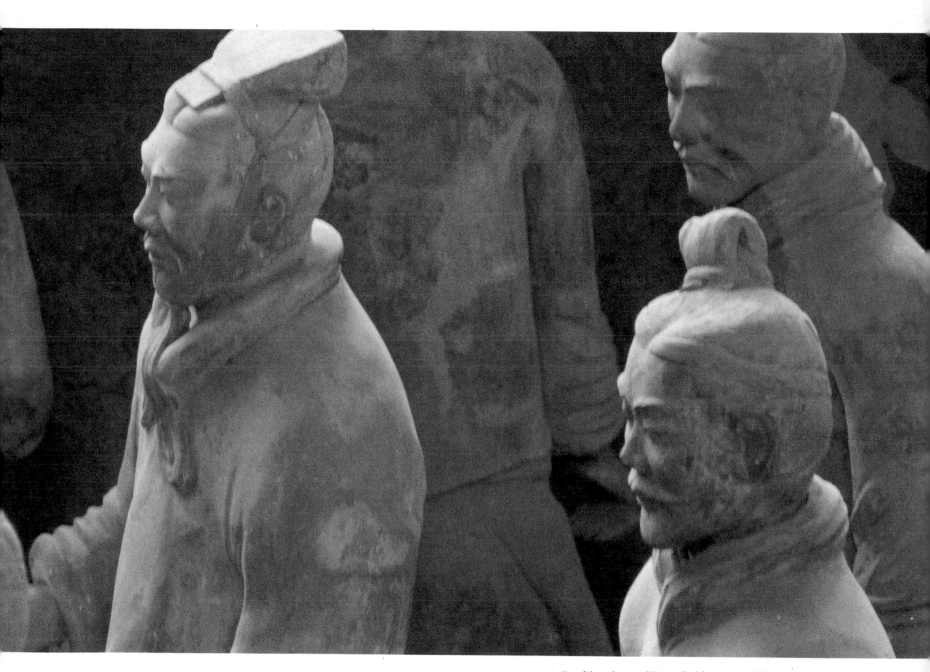

Profile of an officer (left) and soldiers of the vanguard.
Photo by Weng Naiqiang

Three rows of vanguard warriors lead a group of
warriors: rear view of the eastern extremity of Pit No. 1.
Photo by Weng Naiqiang

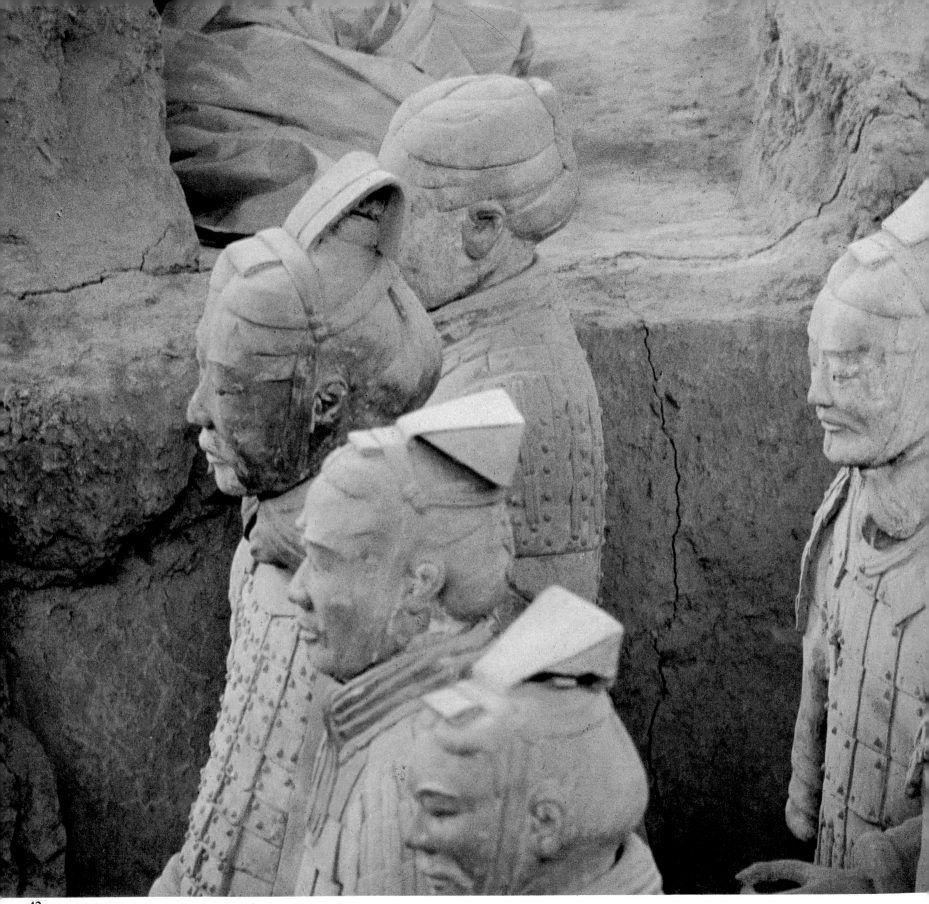

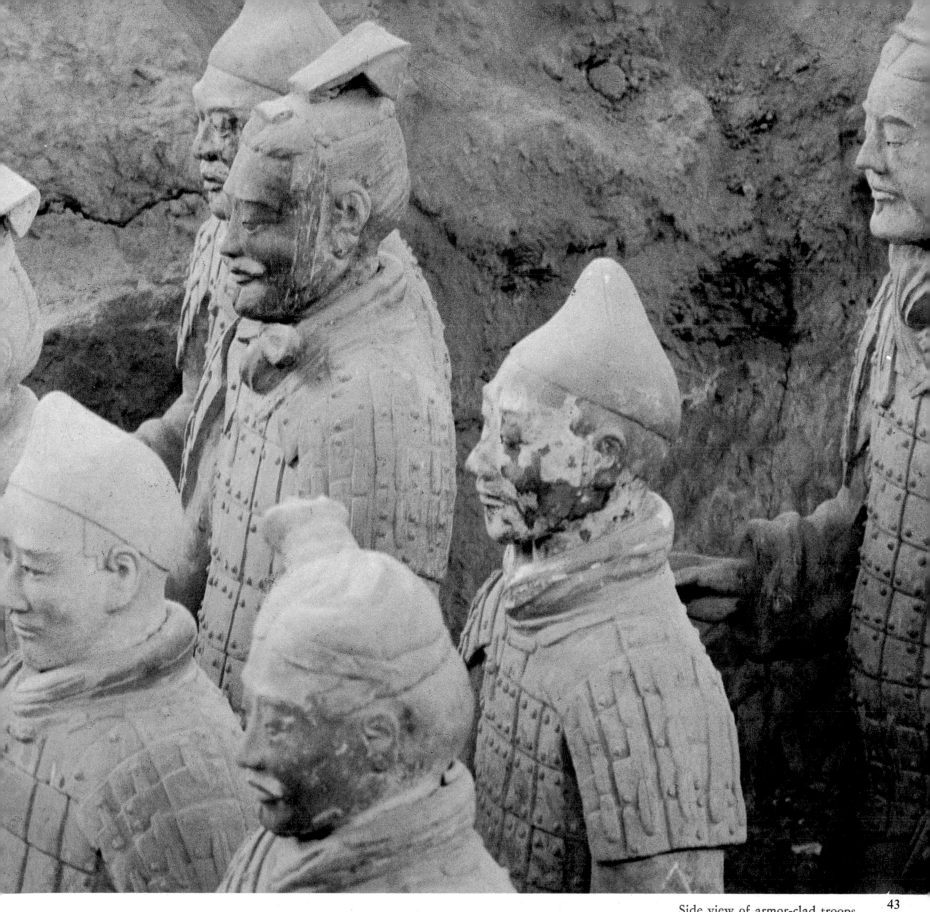

Side view of armor-clad troops.
Photo by Weng Naiqiang

43

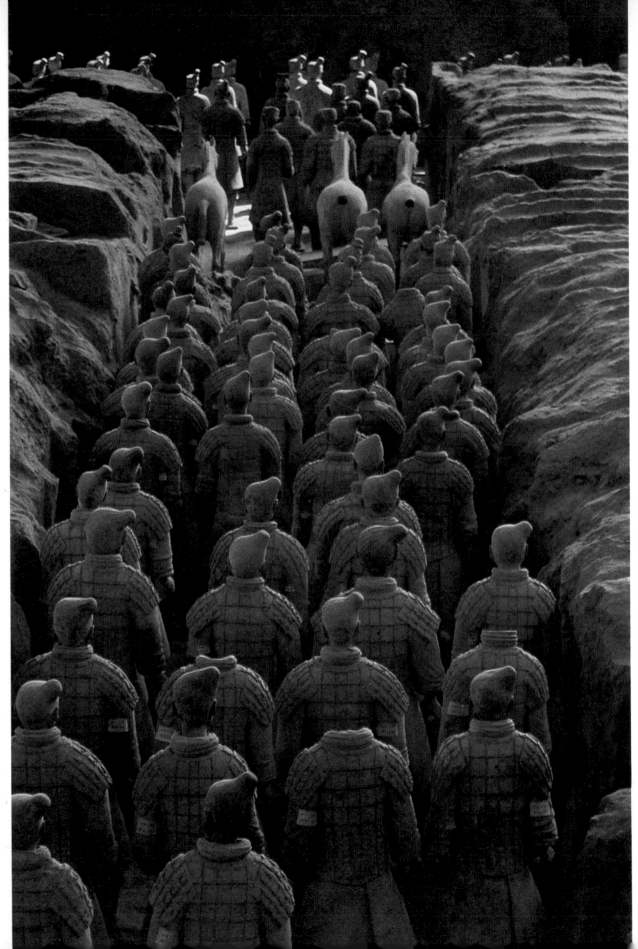

Groups of warriors in the corridors.
Photo by Weng Naiqiang

44

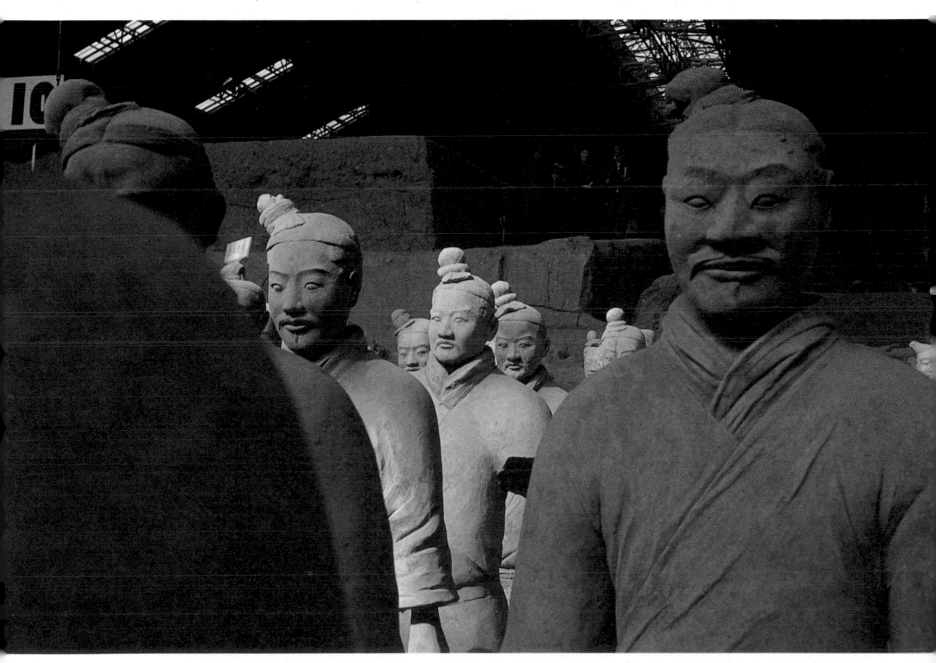

Robed warriors.
Photo by Wang Jingren

45

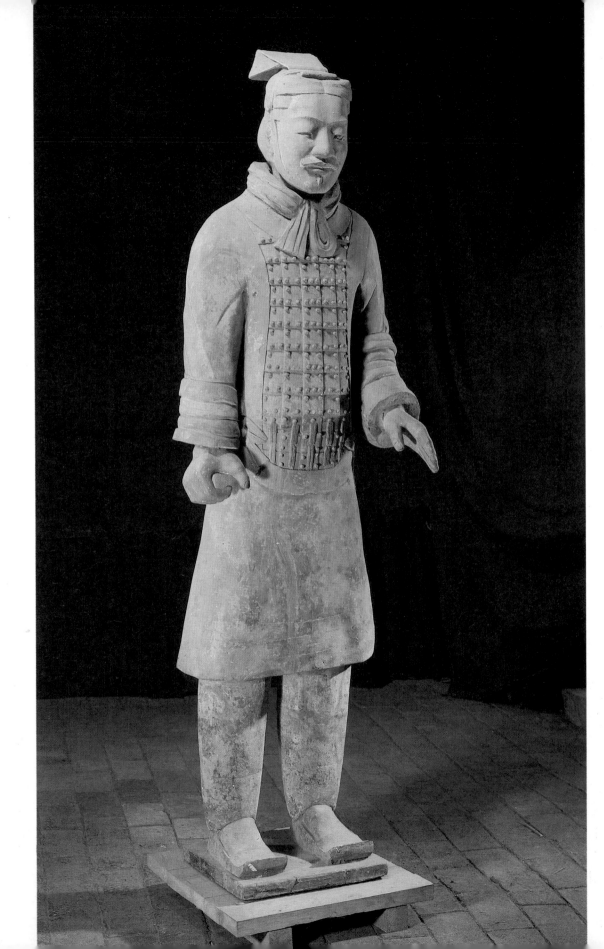

Officer wearing a leather cap with straps tying under the chin.

Photo by Wang Lu

46

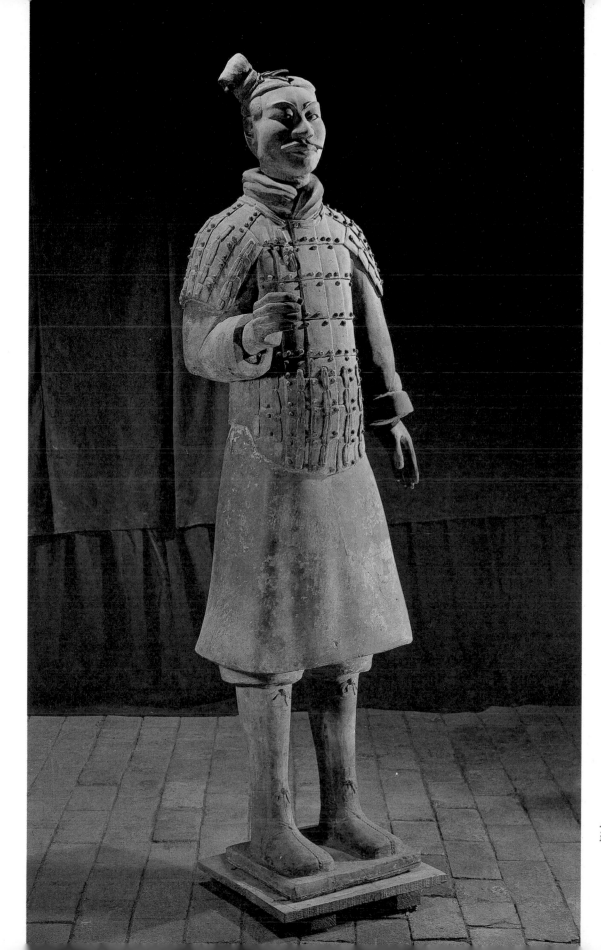

Armor-clad warrior hold-
ing a weapon.
Photo by Wang Lu

47

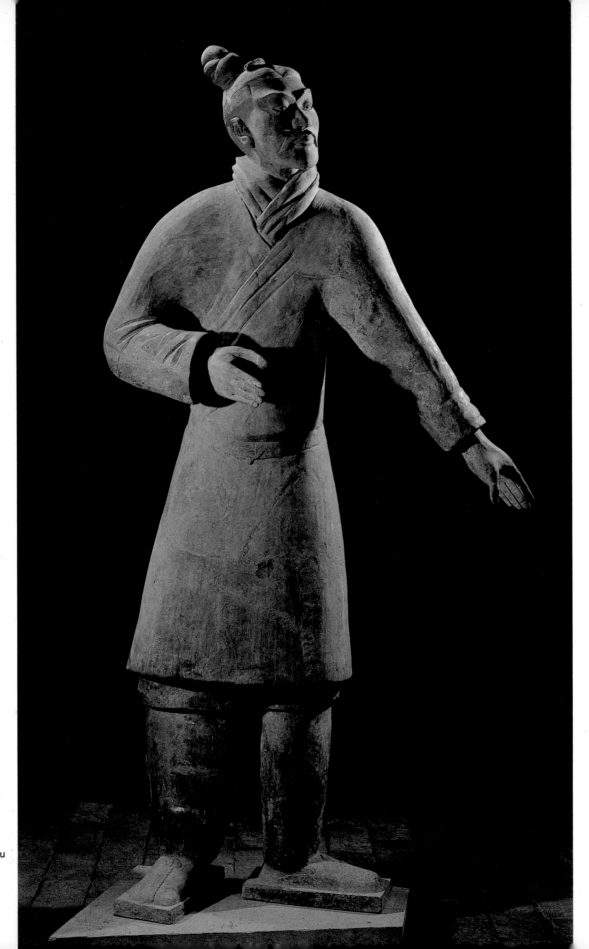

Robed warrior.
Photo by Wang Lu

48

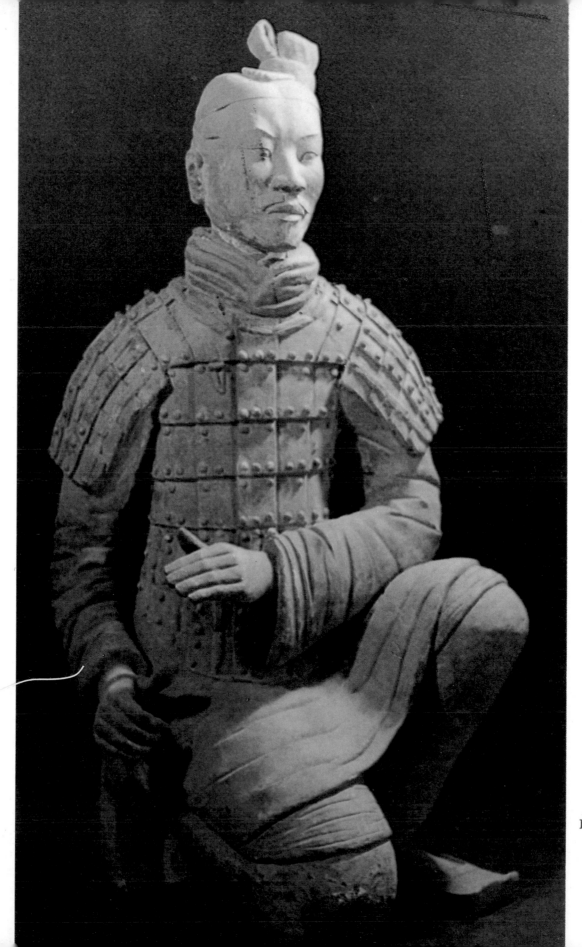

Kneeling archer.

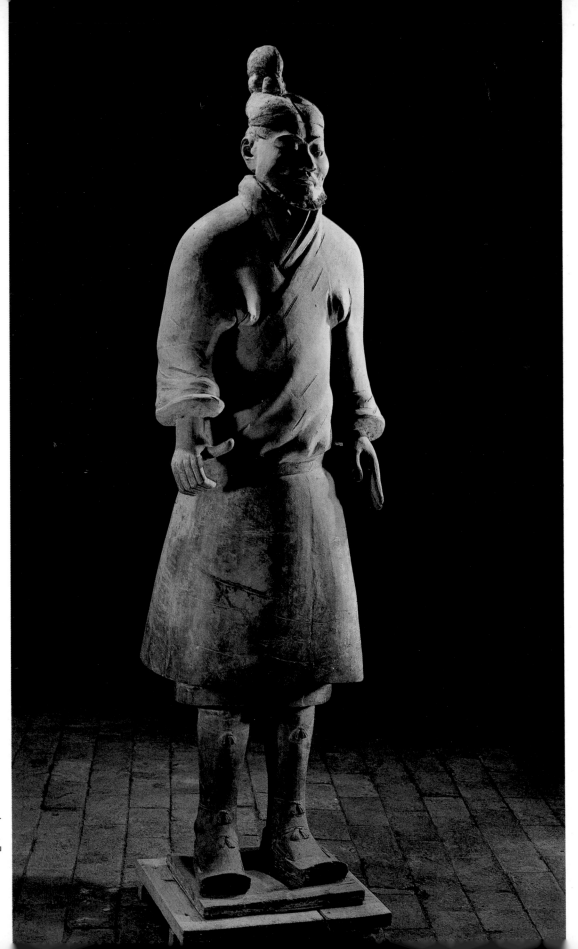

National minority war-
rior in battle robes.
Photo by Wang Lu

50

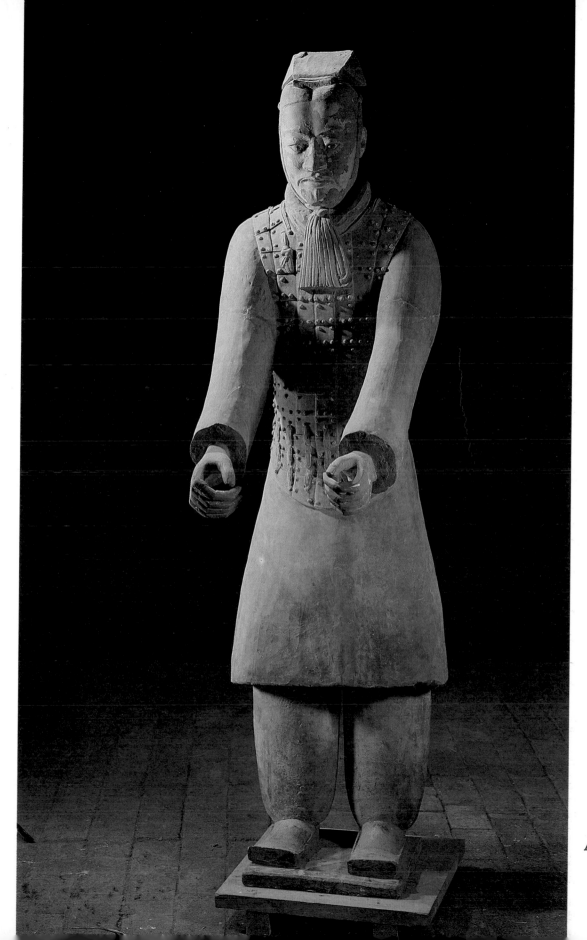

A high-ranking charioteer.
Photo by Wang Lu

51

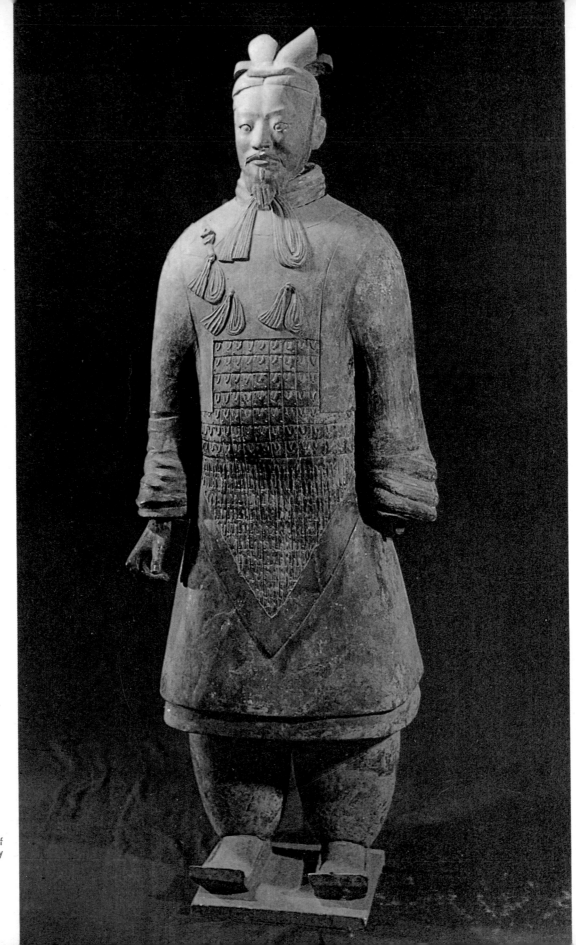

Portrait of a general.
Photo by courtesy of
Xinhua News Agency

52

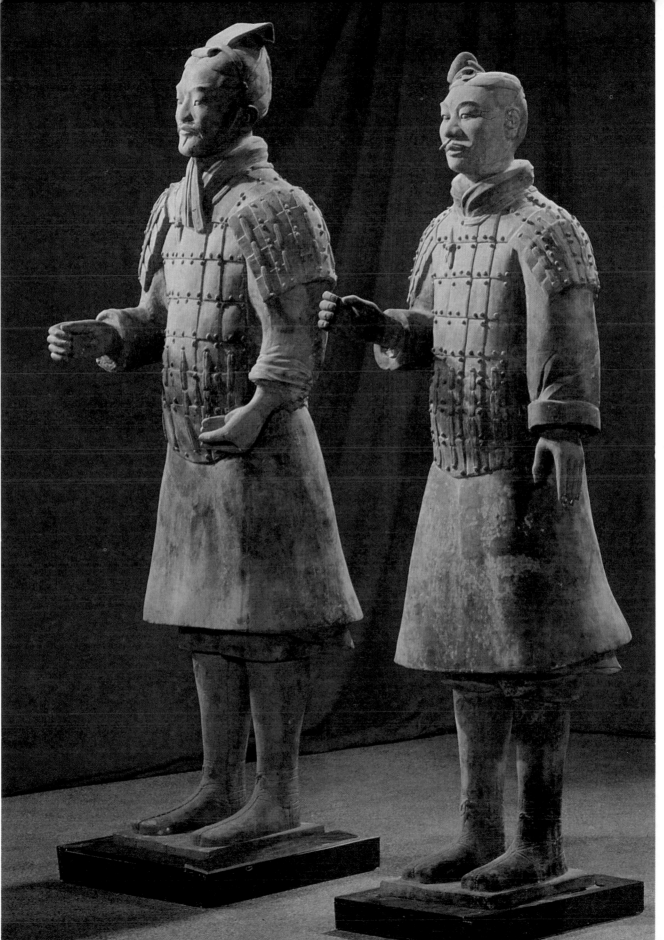

Two warriors.
Photo by Wang Lu

53

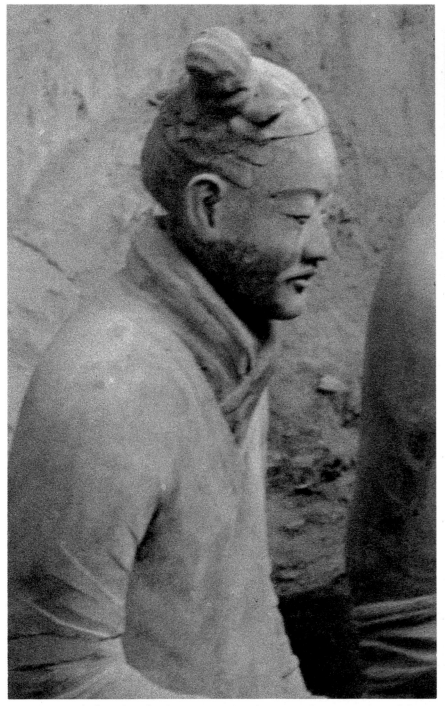

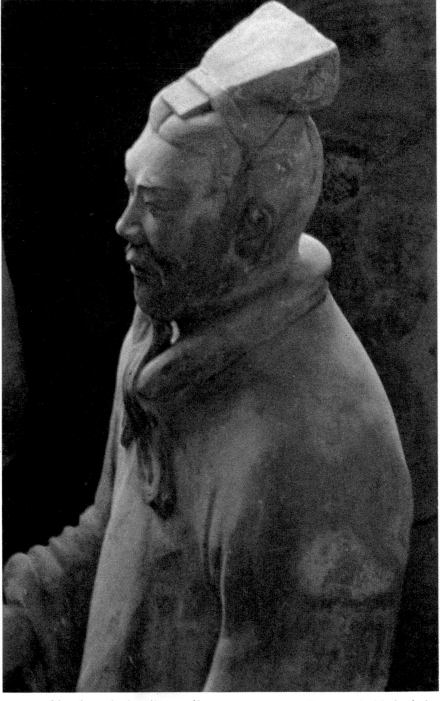

Armor-clad national minority warrior figure with " 田 " shaped face.
Photo by Weng Naiqiang

Profile of a robed military officer wearing a small cap to hold the hair.
Photo by Weng Naiqiang

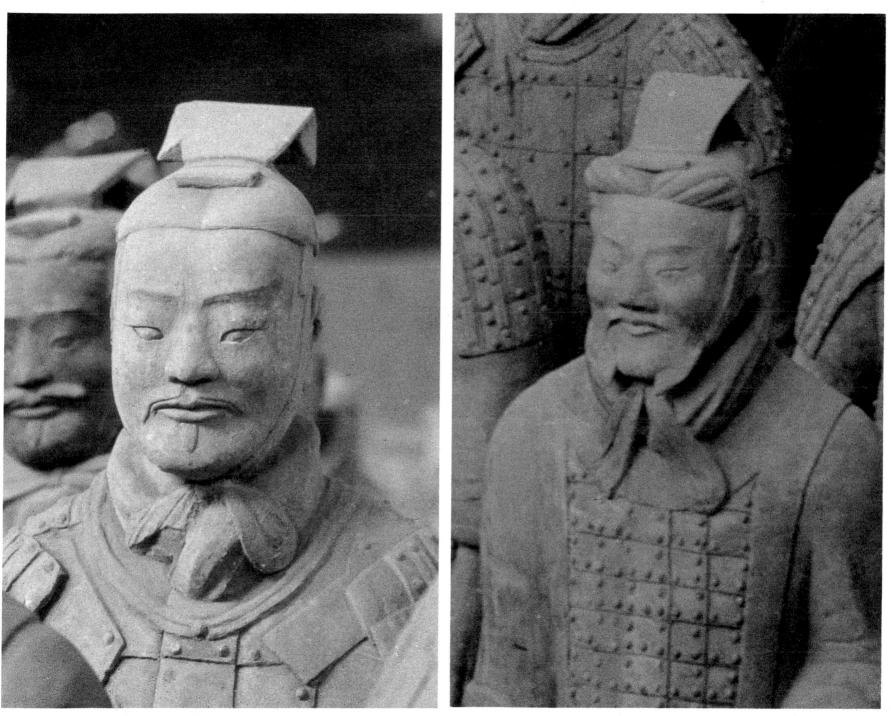

Armor-clad figure with " 国 " shaped face, wearing a small cap to hold the hair.　Photo by Weng Naiqiang

Mongolian troop leader with " 用 " shaped face.
Photo by Weng Naiqiang

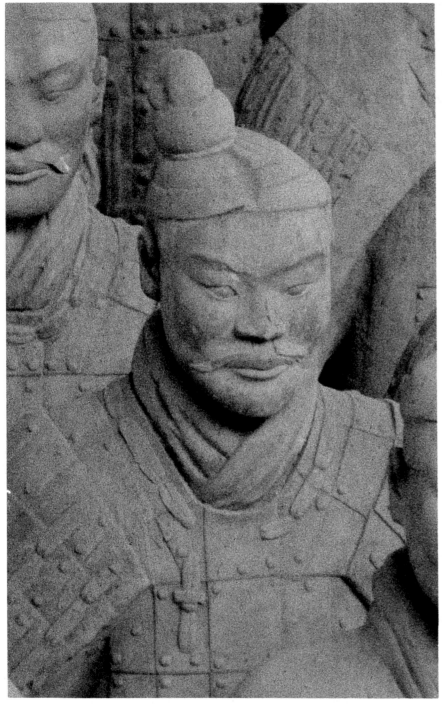

Head of an armor-clad warrior.
Photo by Weng Naiqiang

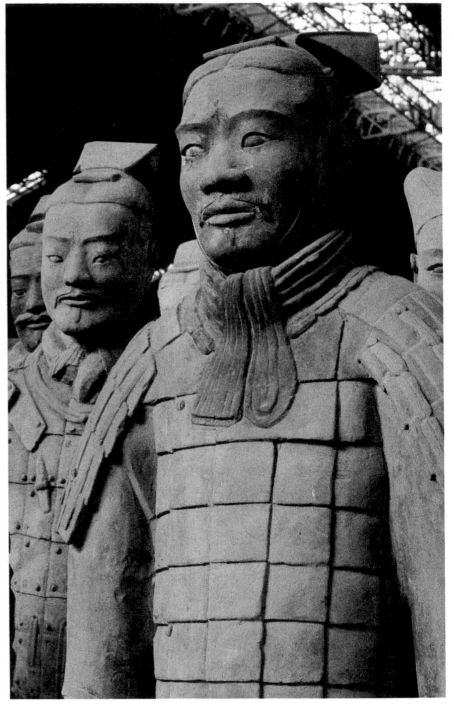

Suave young vanguard warrior.
Photo by Weng Naiqiang

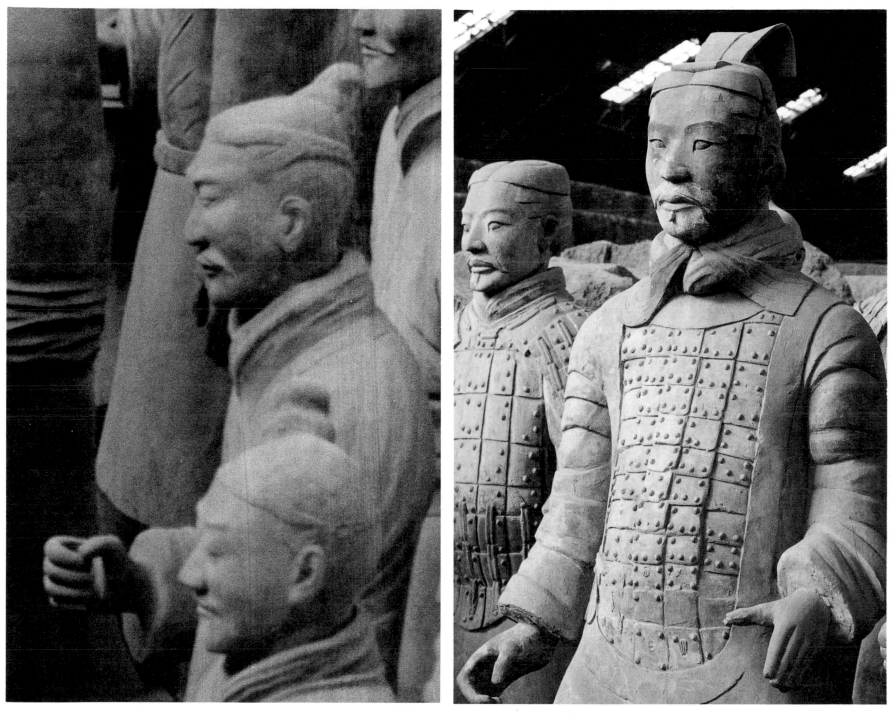

Profile of a vanguard warrior with a small moustache and prominent eyes.

Armor-clad military officer wearing a small cap to hold the hair.

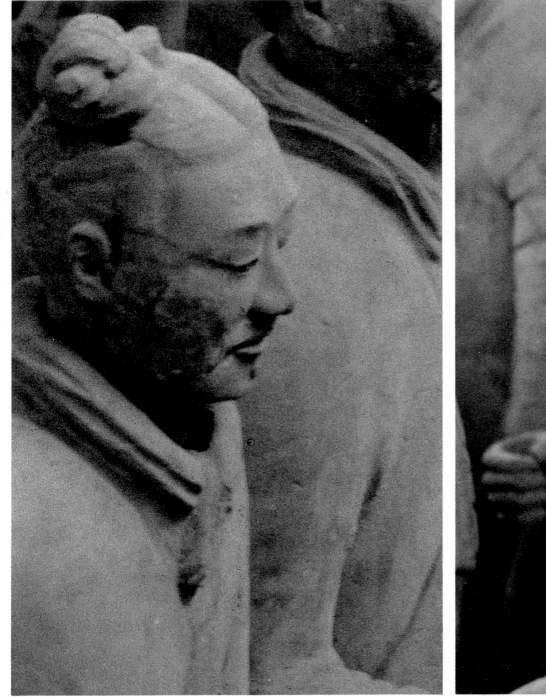

Robed warrior bowing his head in acquiescence.
Photo by Weng Naiqiang

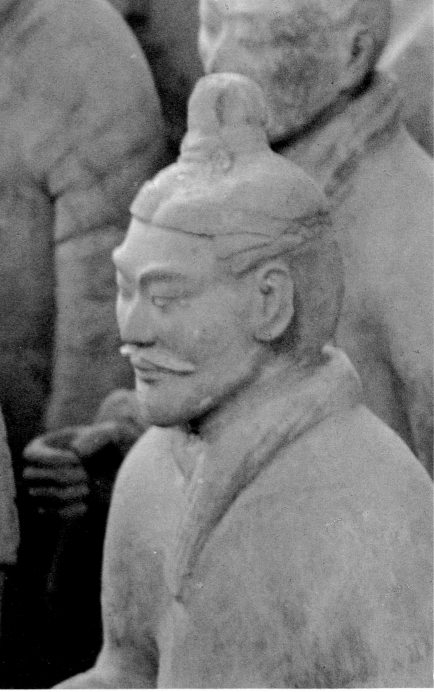

Profile of an armor-clad Shaanxi warrior with a short nose and lower jaw.

Photo by Weng Naiqiang

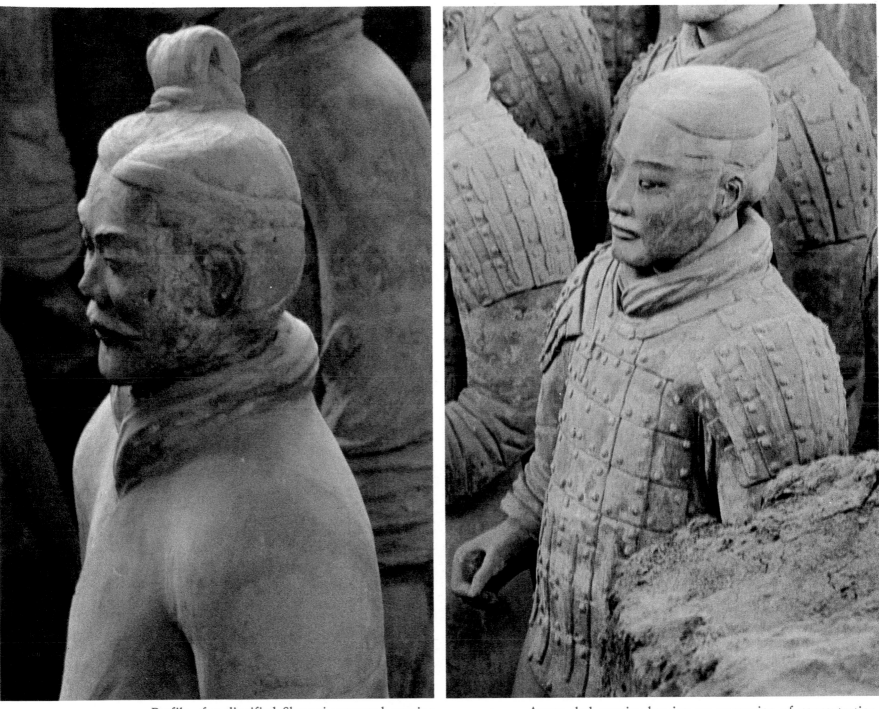

Profile of a dignified Shaanxi vanguard warrior.
Photo by Weng Naiqiang

Armor-clad warrior bearing an expression of concentration.
Photo by Weng Naiqiang

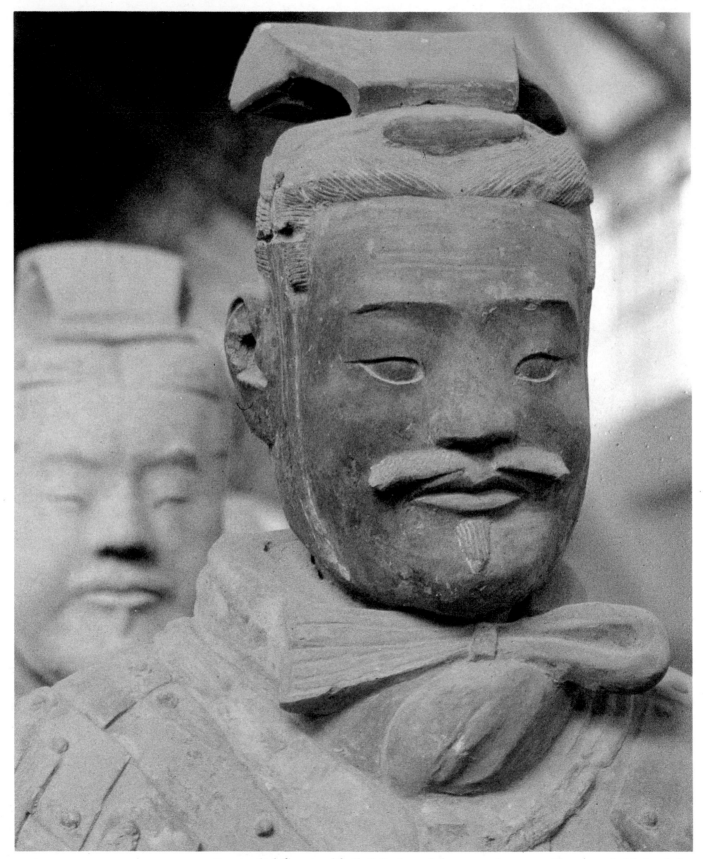

Armor-clad figure with " 目 " shaped face wearing a small cap to hold the hair.

Photo by Weng Naiqiang

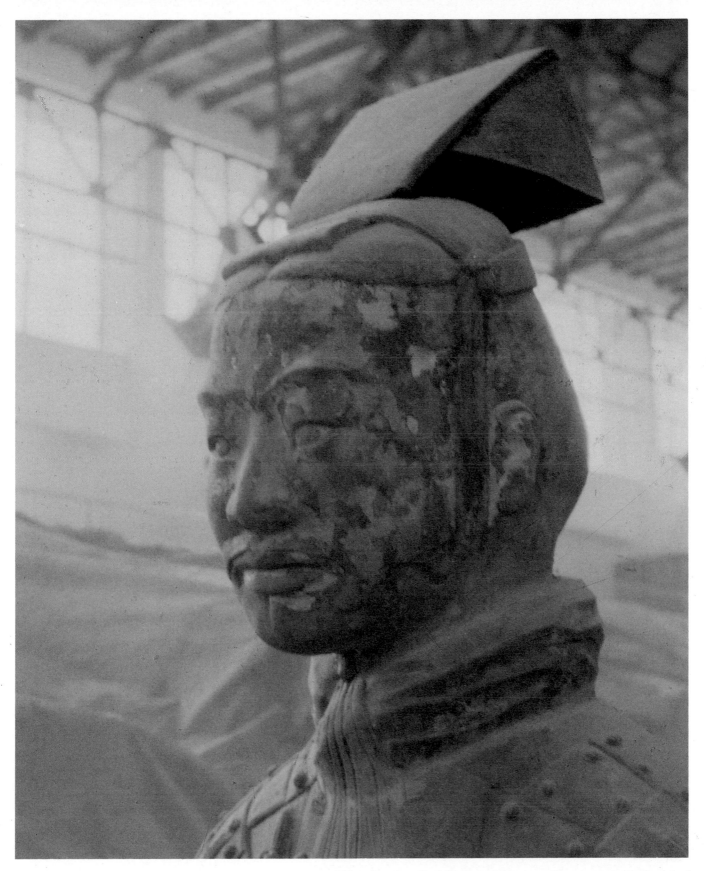

Profile of armor-clad figure wearing small cap to hold the hair.

Photo by Wang Jingren

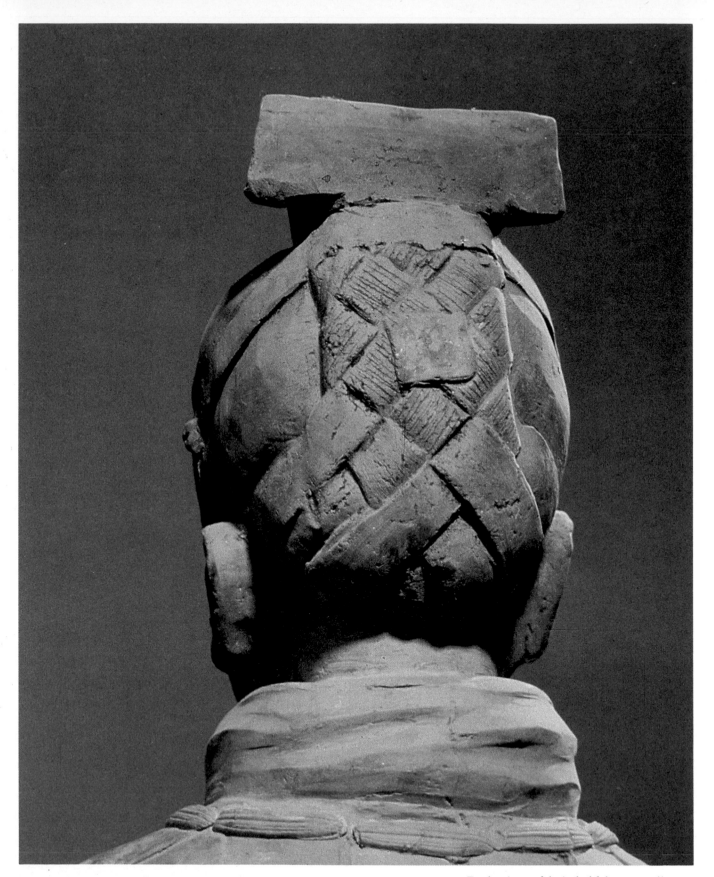

Back view of hair held by a small cap.

Photo by Wang Lu

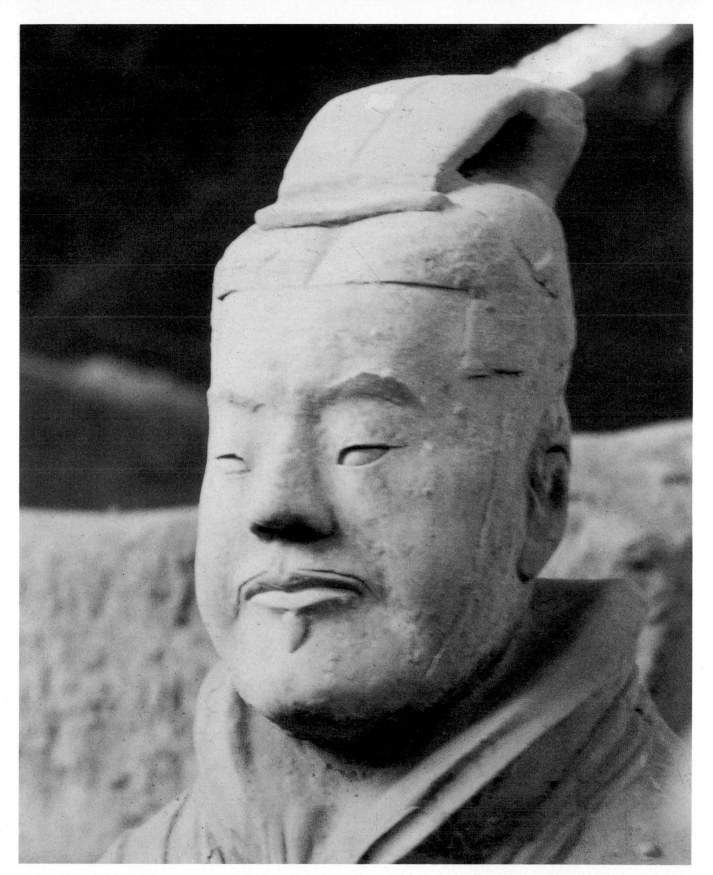

A plump and genteel military officer.

Photo by Weng Naiqiang

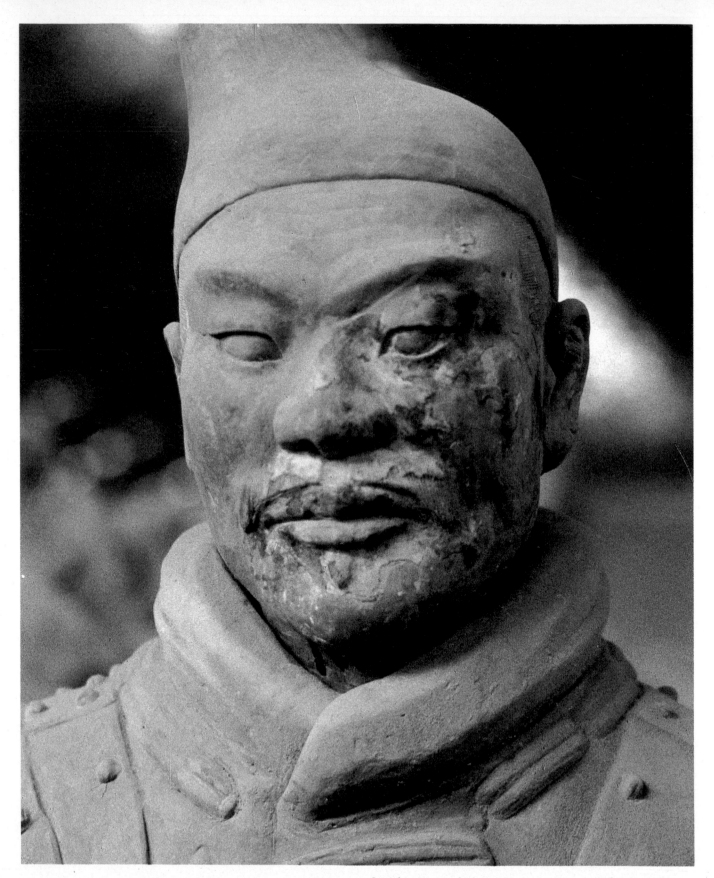

Sturdy armor-clad warrior wearing a soft, round cap.

Photo by Weng Naiqiang

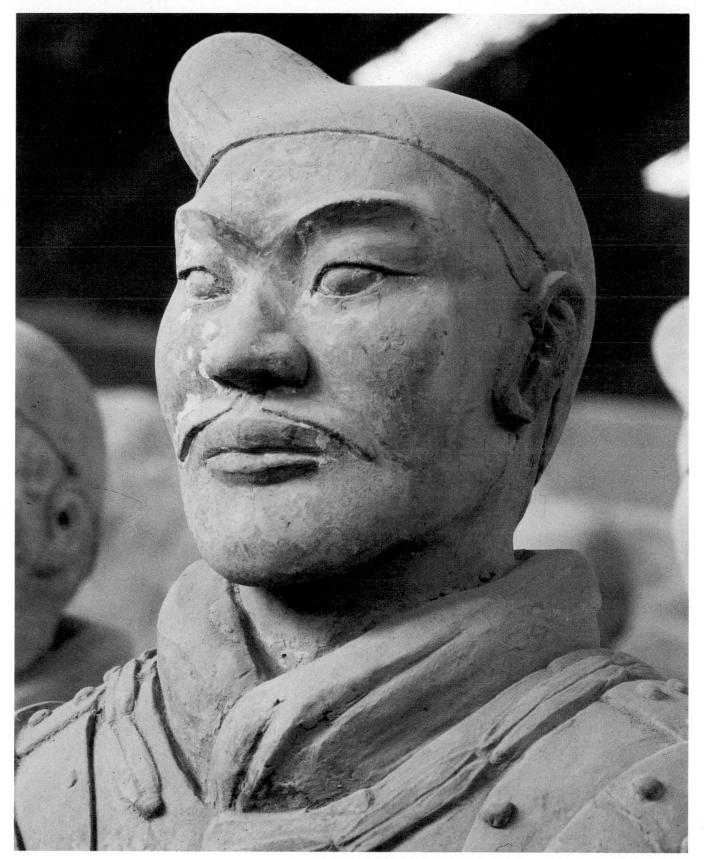

Armor-clad warrior in a soft round cap awaiting orders.

Photo by Weng Naiqiang

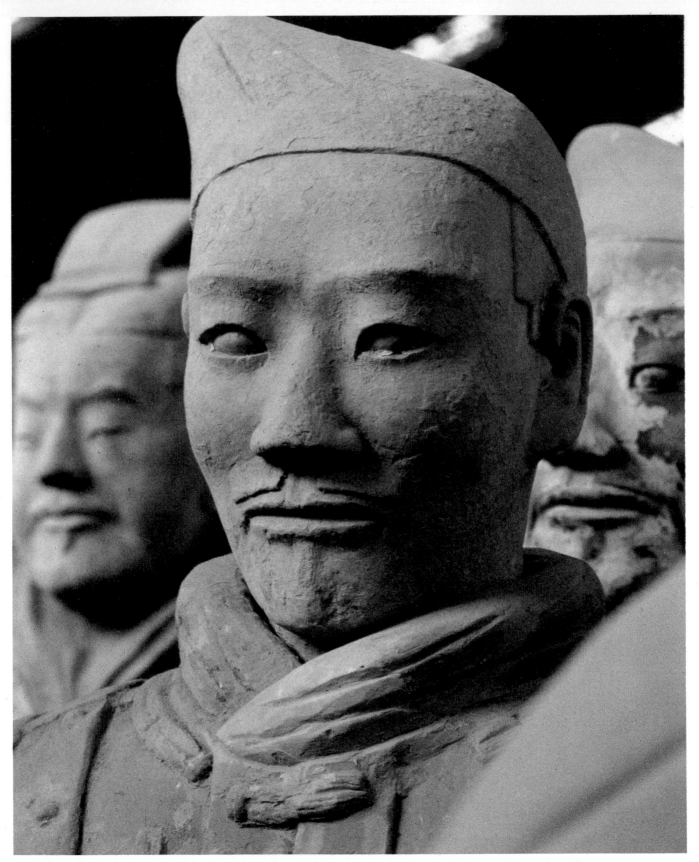

Vigilant Sichuanese soldier in a soft cap.

Photo by Weng Naiqiang

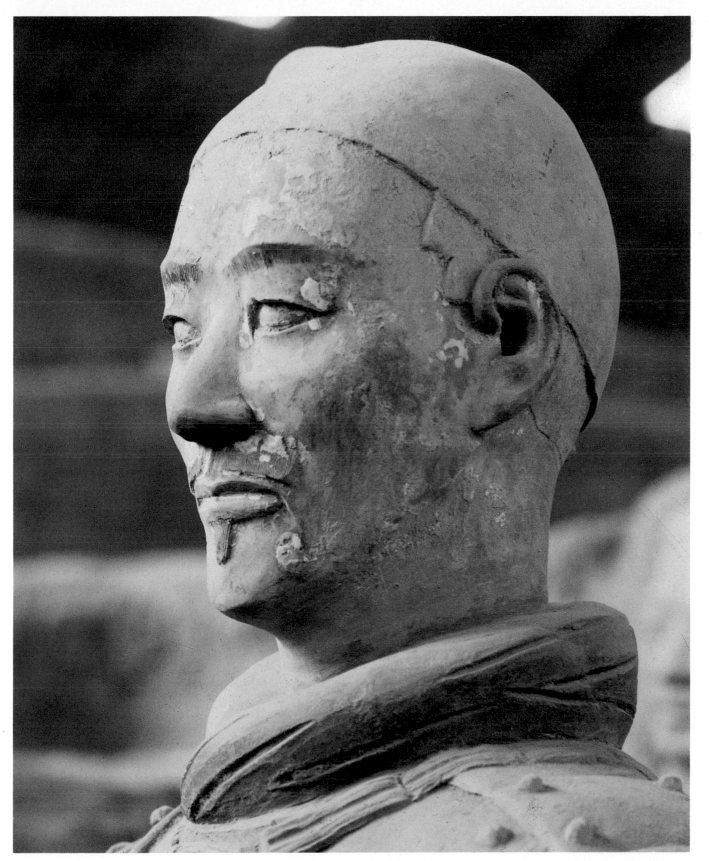

Profile of an armor-clad warrior wearing a round cap.

Photo by Weng Naiqiang

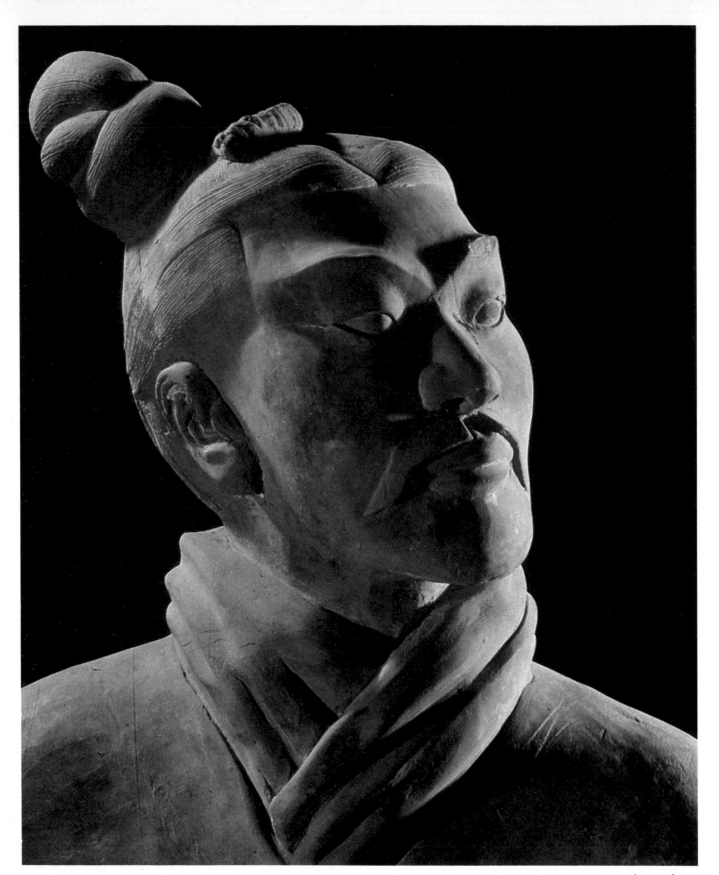

An archer.

Photo by Weng Naiqiang

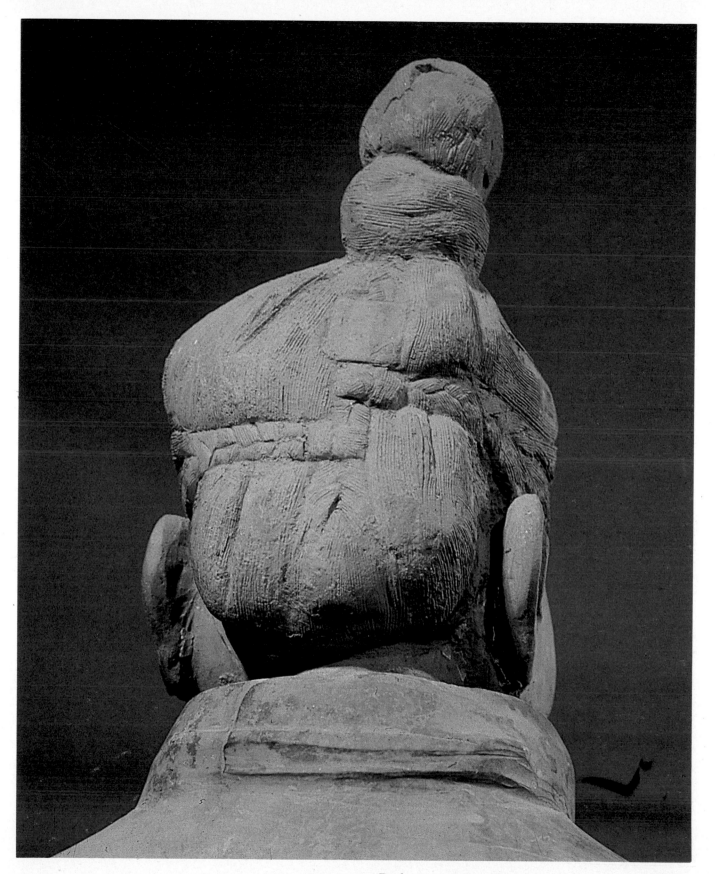

Back view of the coiled hairstyle of a warrior figure.
Photo by Wang Lu

69

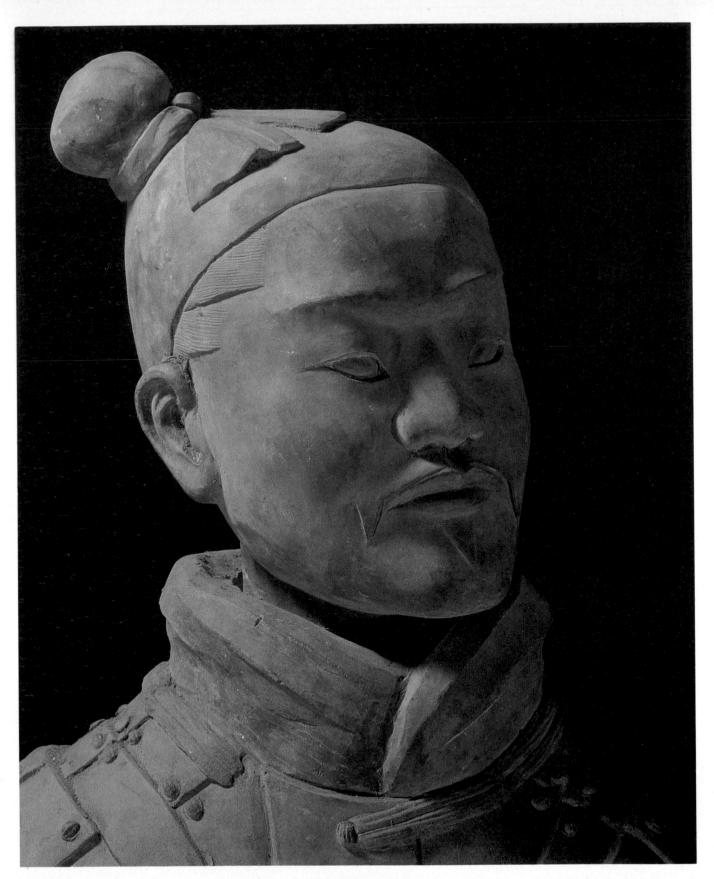

Armor-clad warrior with a long lower jaw, high cheekbones and prominent forehead.

Photo by Wang Lu

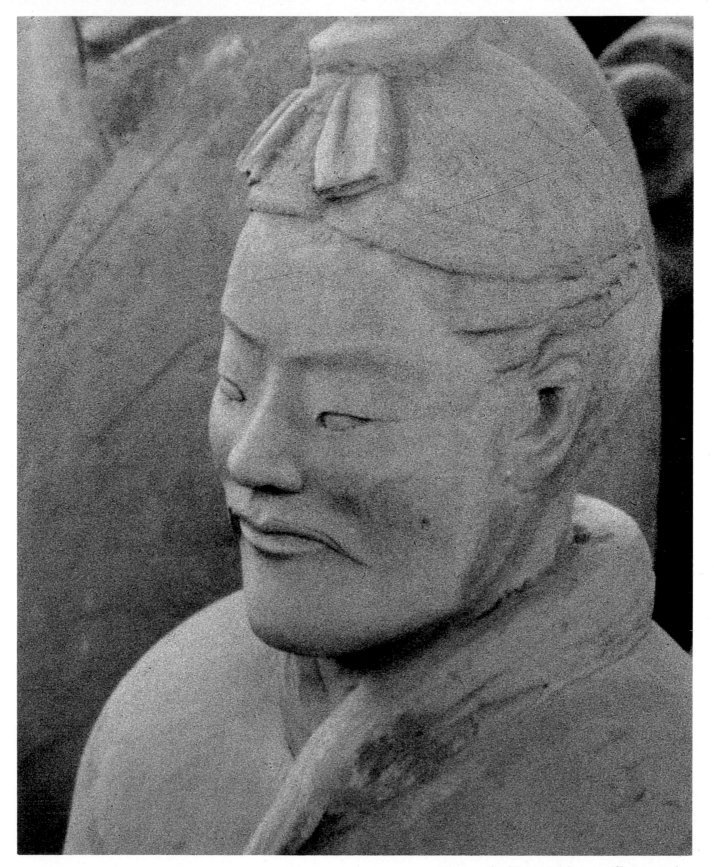

Vanguard warrior with a small moustache.
Photo by Weng Naiqiang

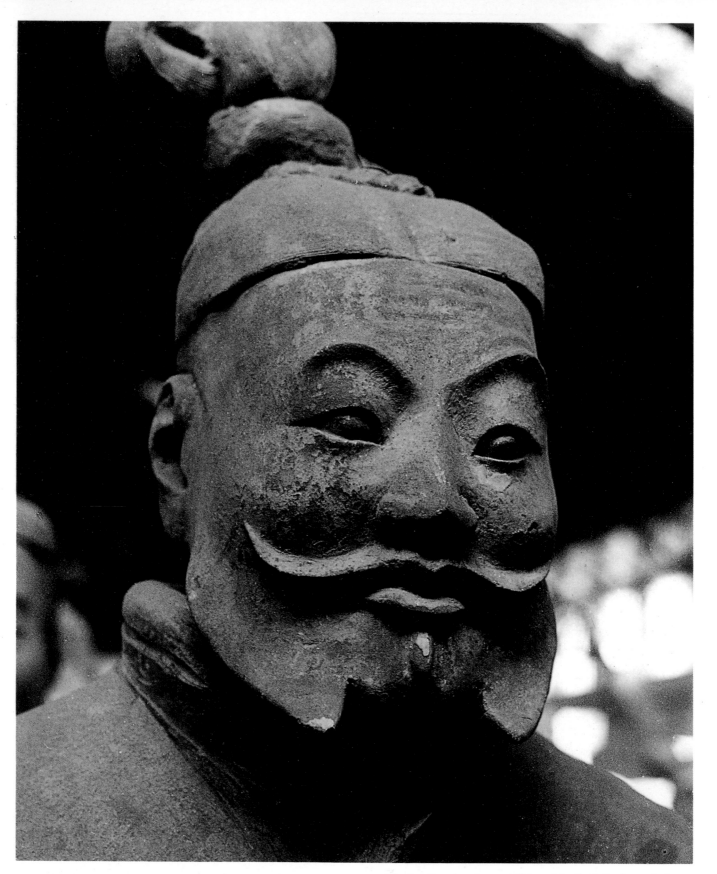

National minority soldier with " 凤 " shaped face.

Photo by Li Xing

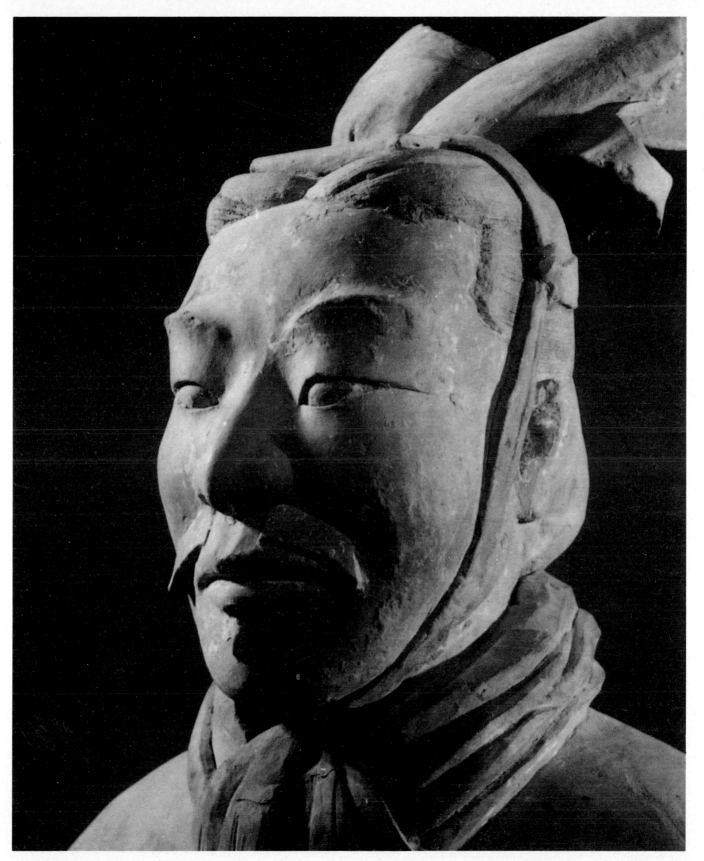

Robed warrior with " 申 " shaped face.

Photo by Li Xing

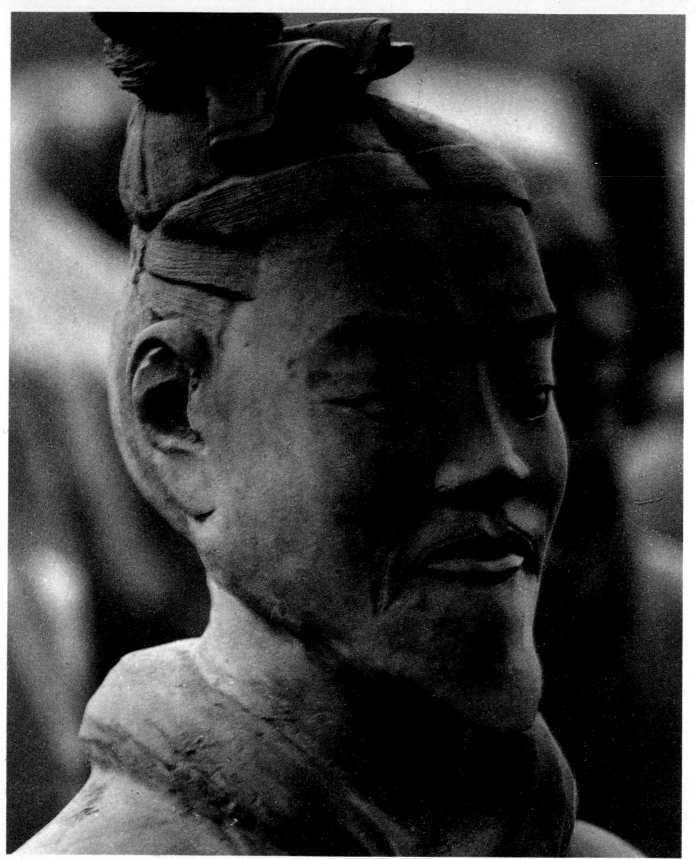

Profile of a low ranking military officer.

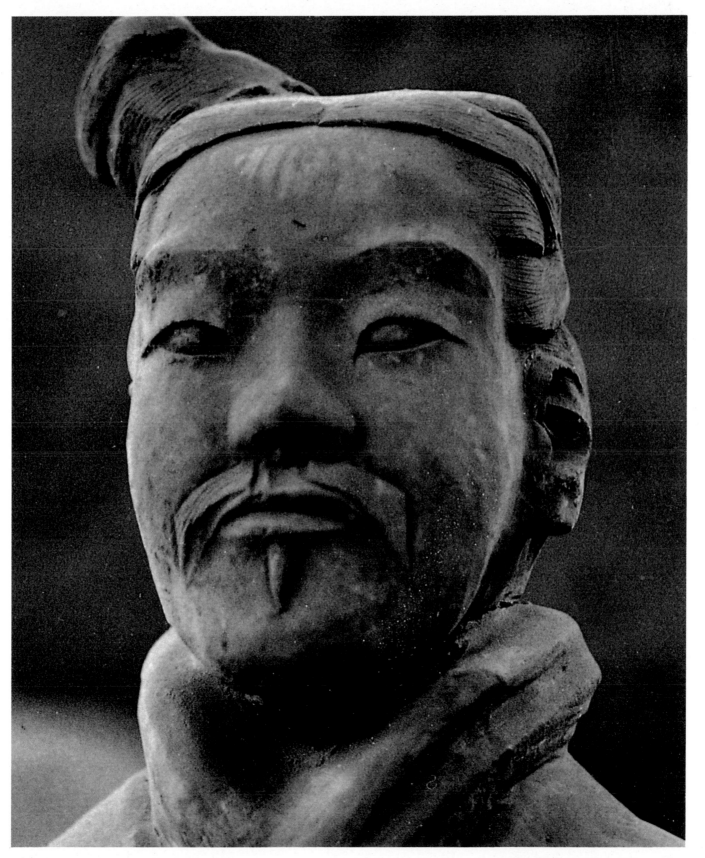

A dignified middle-aged warrior.

Photo by Wang Tianyu

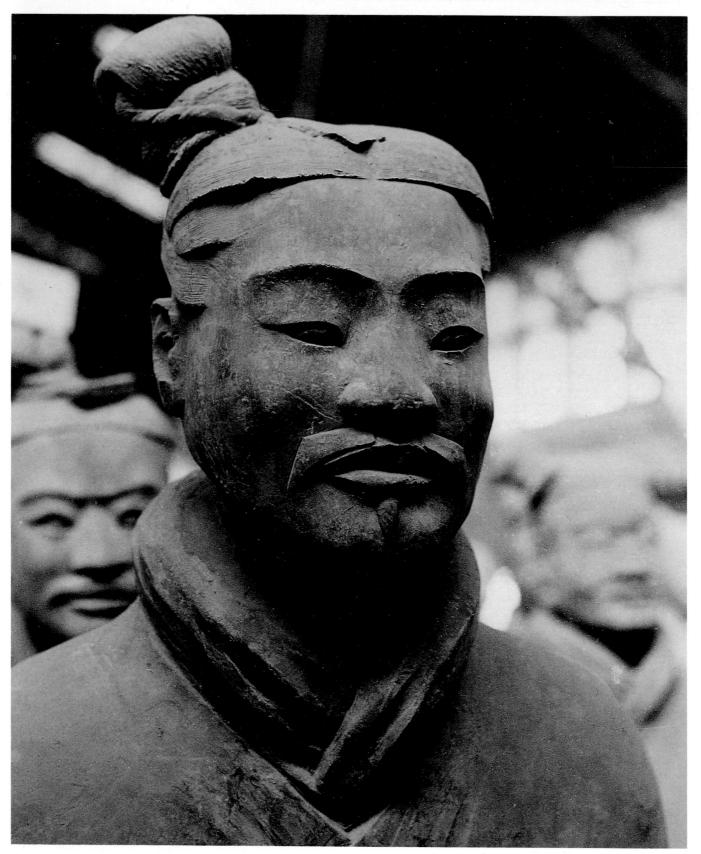

An experienced vanguard fighter.

Photo by Li Xing

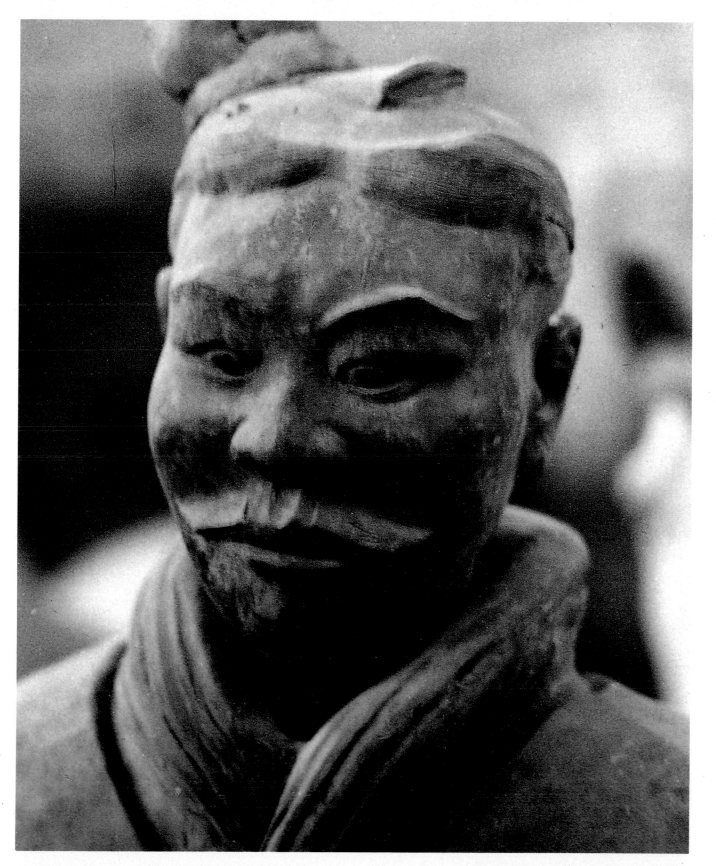

Vanguard warrior smiling nervously.
Photo by Wang Tianyu

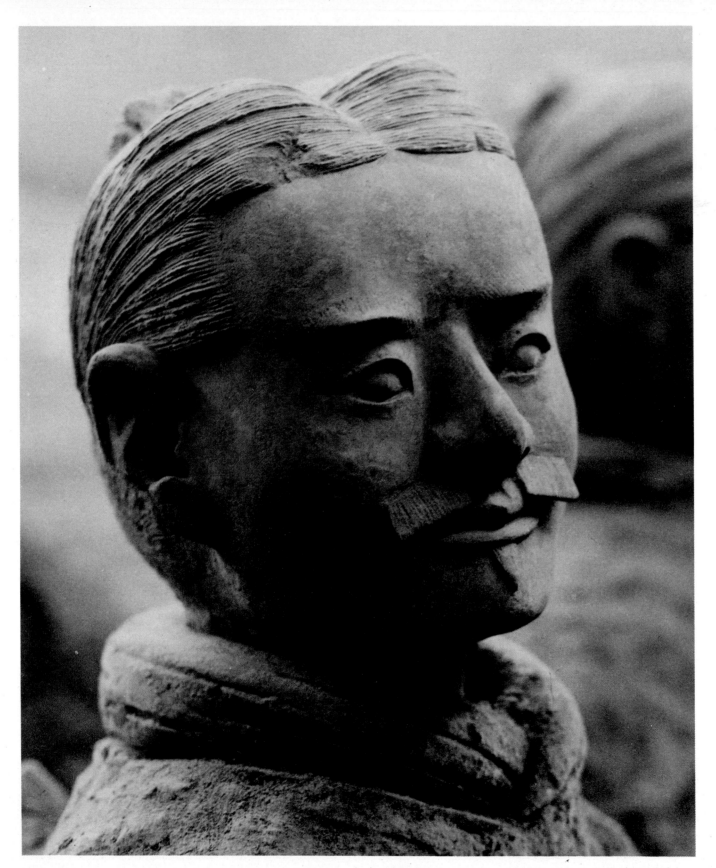

National minority warrior with " 田 " shaped face.

Photo by Wang Tianyu

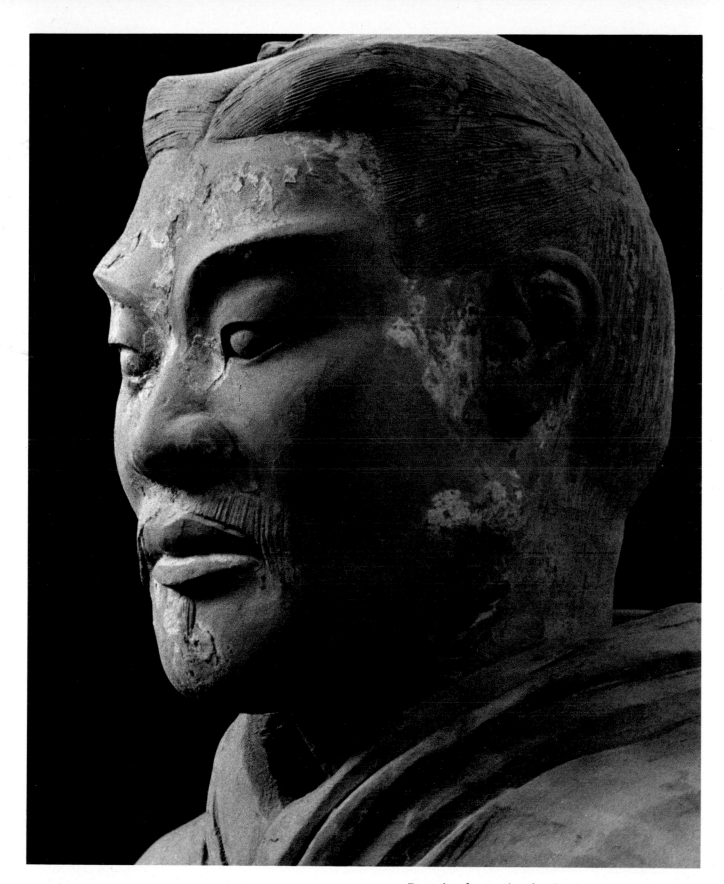

Portrait of a national minority vanguard warrior.

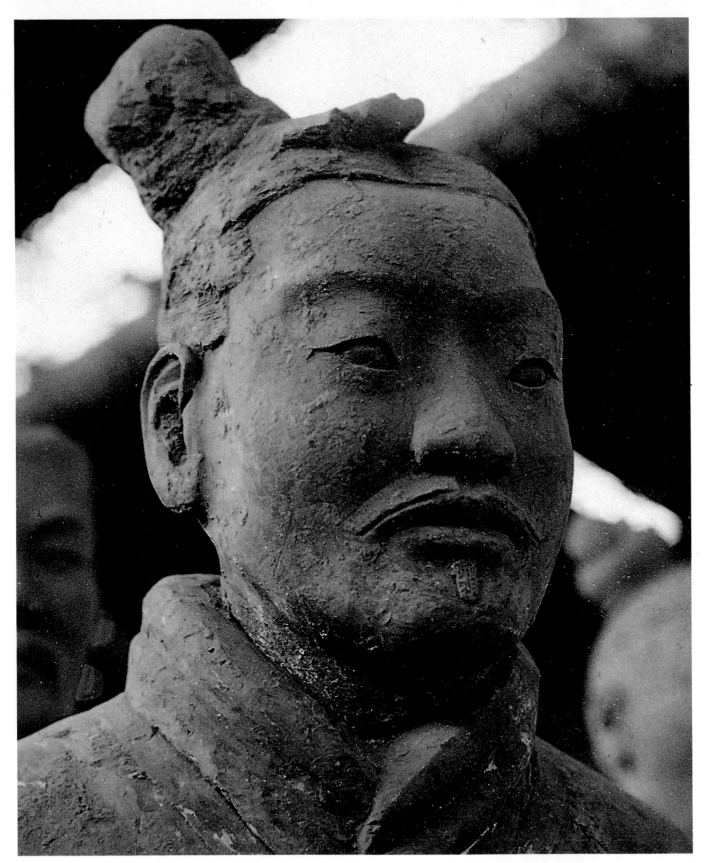

Robed warrior with " 自 " shaped face.

Photo by Li Xing

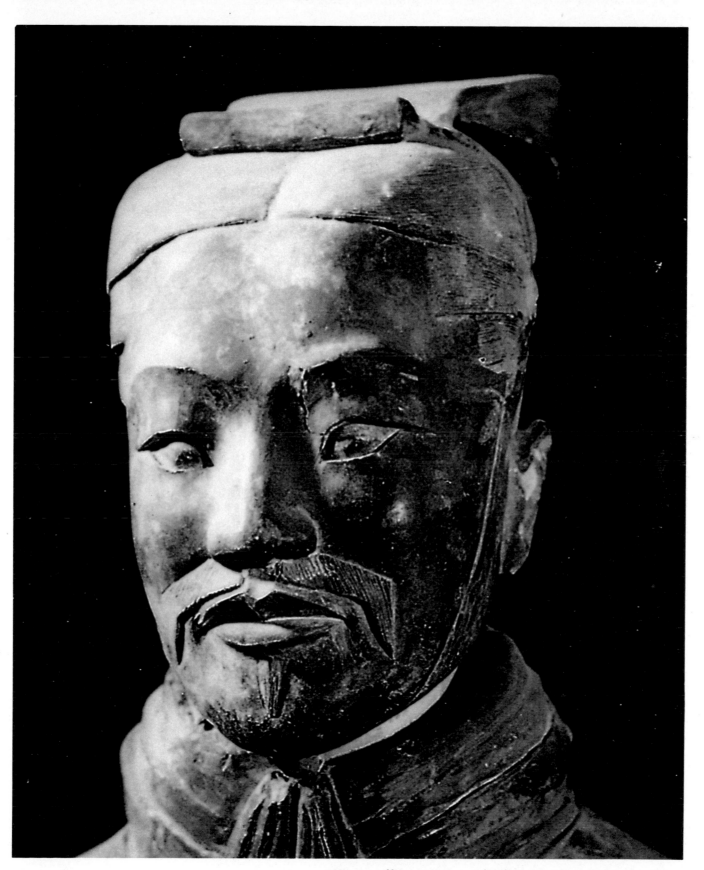

Military officer wearing a leather cap tying under the chin.

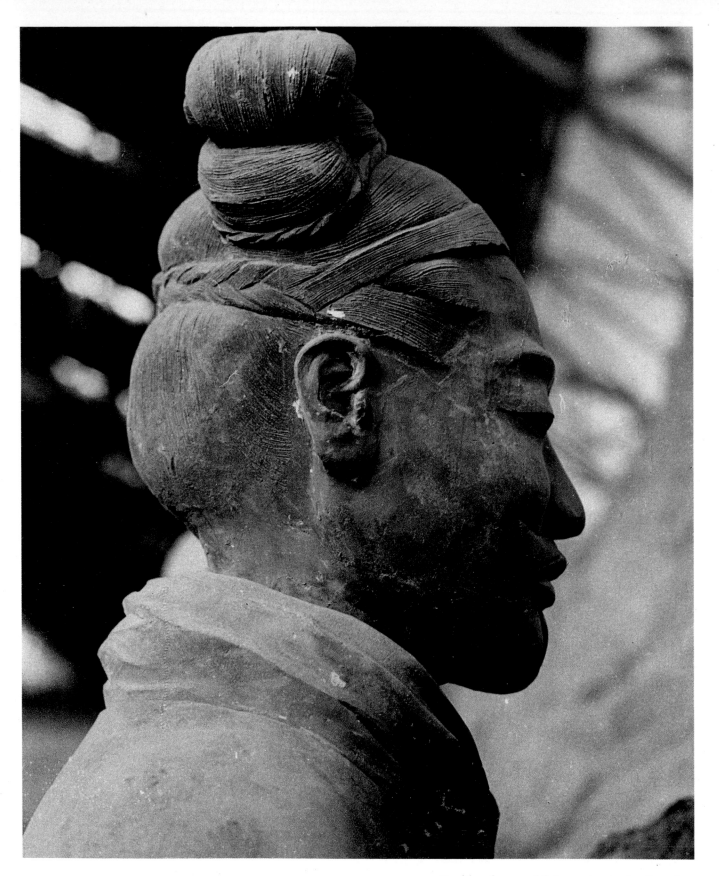

Profile of a youthful warrior in battle robes.

82

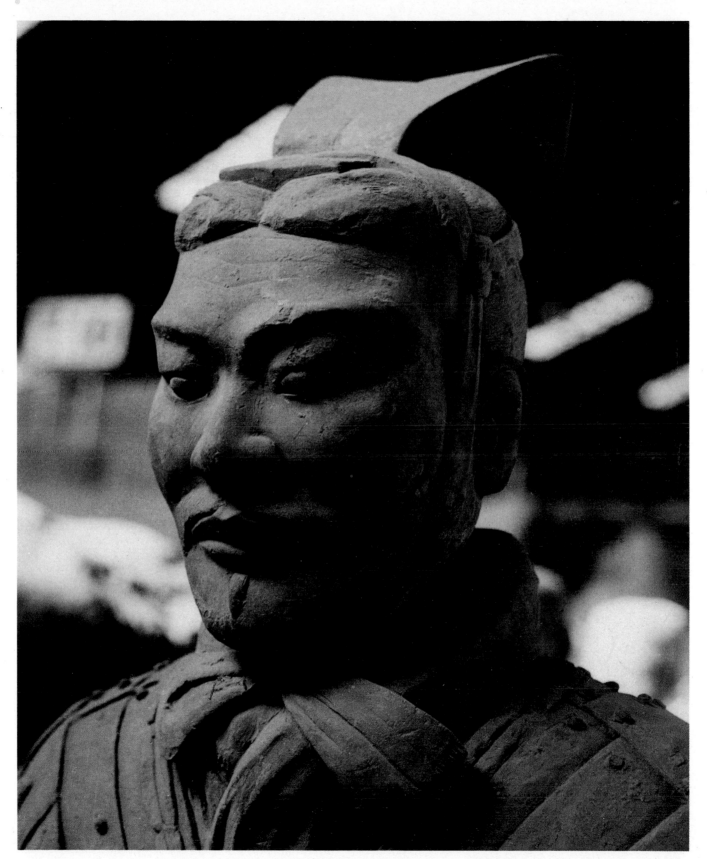

Military officer engrossed in thought.

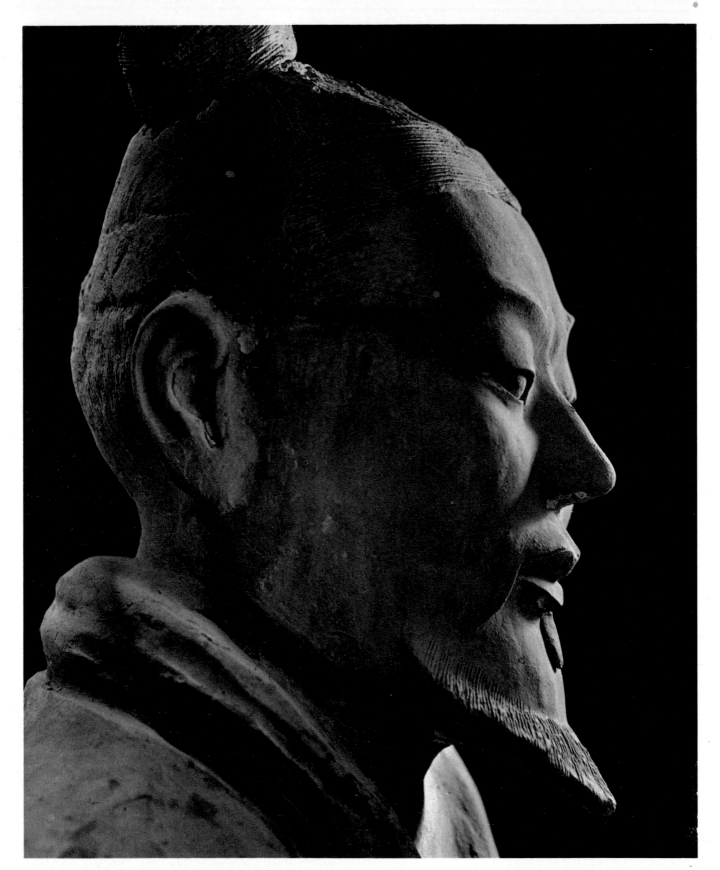

Experienced vanguard warrior.
Photo by Wang Tianyu

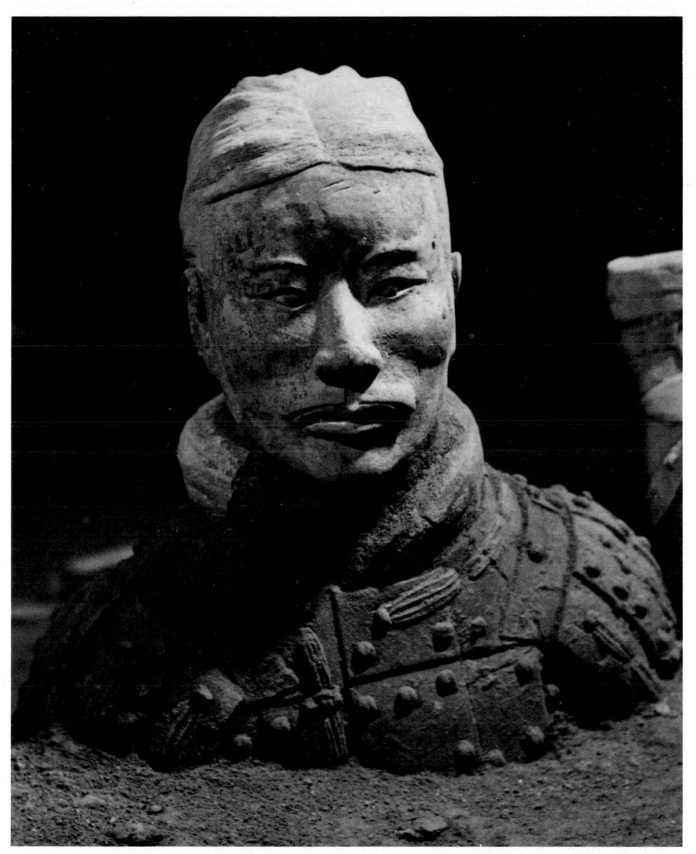

Newly excavated armor-clad warrior figure.
Photo by courtesy of Xinhua News Agency

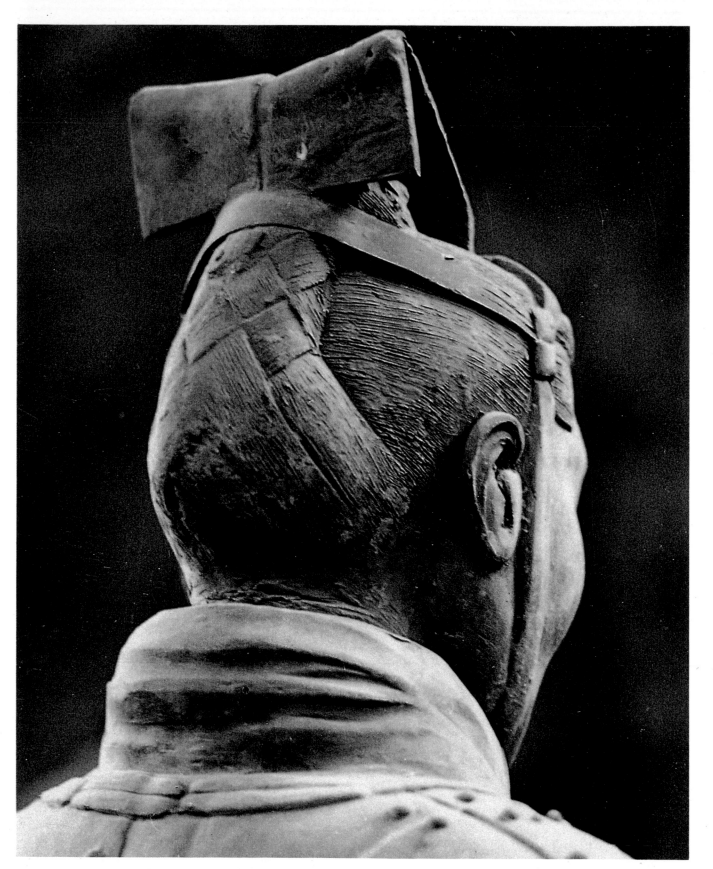

Rear view of hair held by a small cap.

Photo by Wang Tianyu

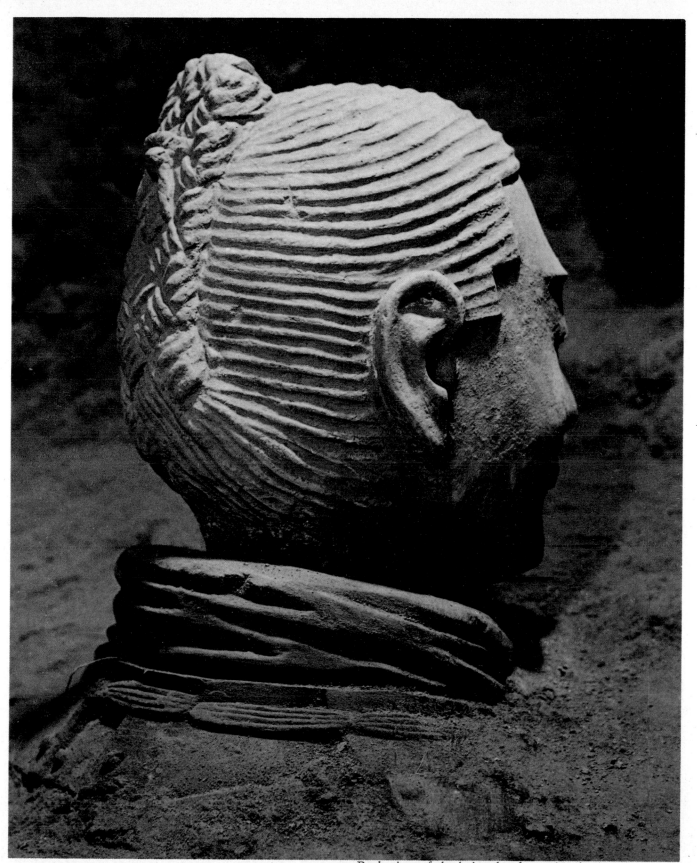

Back view of the hairstyle of a national minority warrior.

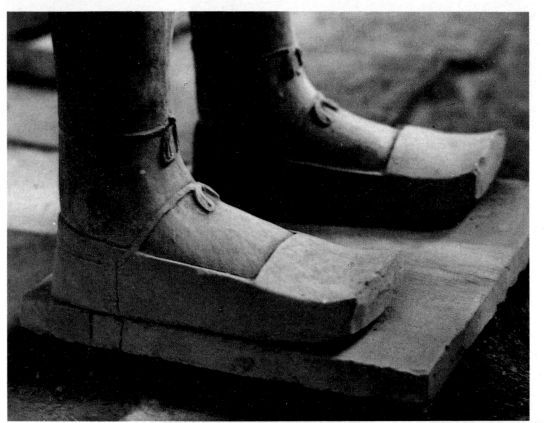

Detail of footwear (1).
Photo by Wang Jingren

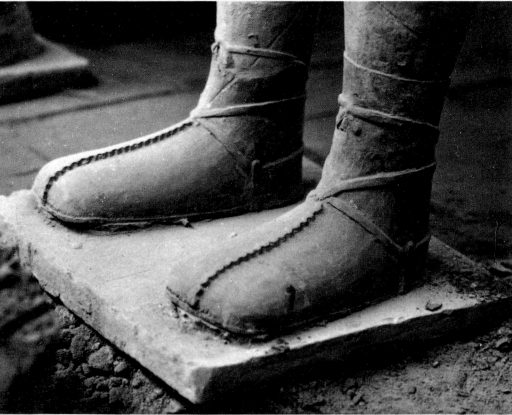

Detail of footwear (2).
Photo by Wang Jingren

4. Terracotta Horses and Charioteers

The triumphant armies of Qin Shi Huang, which defeated the forces of six eastern kingdoms and unified China for the first time were outfitted with finely wrought military equipment. During the Warring States period (403-221 B.C.), war chariots and horses were the principal criterion for measuring the military strength of a kingdom and constituted the main heavy weaponry of an army.

The appearance of horses on the battlefield in ancient China marked the evolution of the art of war from the original primitive treking and fighting on foot to a new stage of development. The wooden chariots found in Pit No. 1 were pulled by a team of four life-size terracotta horses. The horses stand 1.5 meters high and are 2 meters long. They are harnessed in a single row with two inner and two outer steeds.

The chariot has square-shaped carriage approximately 150 cm. wide and 120 cm. long, with traces of railings on each side. A single shaft with a crossbar ran between the two inner horses. Originally two armored warriors stood in the chariot, while in front of the horses there were three rows of four armored warriors holding bronze spears and other weapons. One of these warrior also carried a bronze sword at his waist. Additional warriors were deployed to the rear of the chariot.

Warriors, chariots and horses stand in line rank upon rank within the trenches with a space of approximately 70 cm. between each rank and 60 cm. between the figures in the same rank. Such a vast array of stalwart warriors and robust horses suggests the might and grandeur of the Qin army.

The war chariots in Pit No. 2 also have single shafts 37 cm. long and 8 to 16 cm. in diameter. Four horses are harnessed to a 120 cm.-long crossbar. Warriors in groups of 2 or 3 stand behind the chariots. The horse figures ridden by the cavalry measure 1.72 meters tall and 2.03 meters long with long, plaited tails. Their saddles were fashioned to appear like leather. The horses' manes are adorned with flowery decorations.

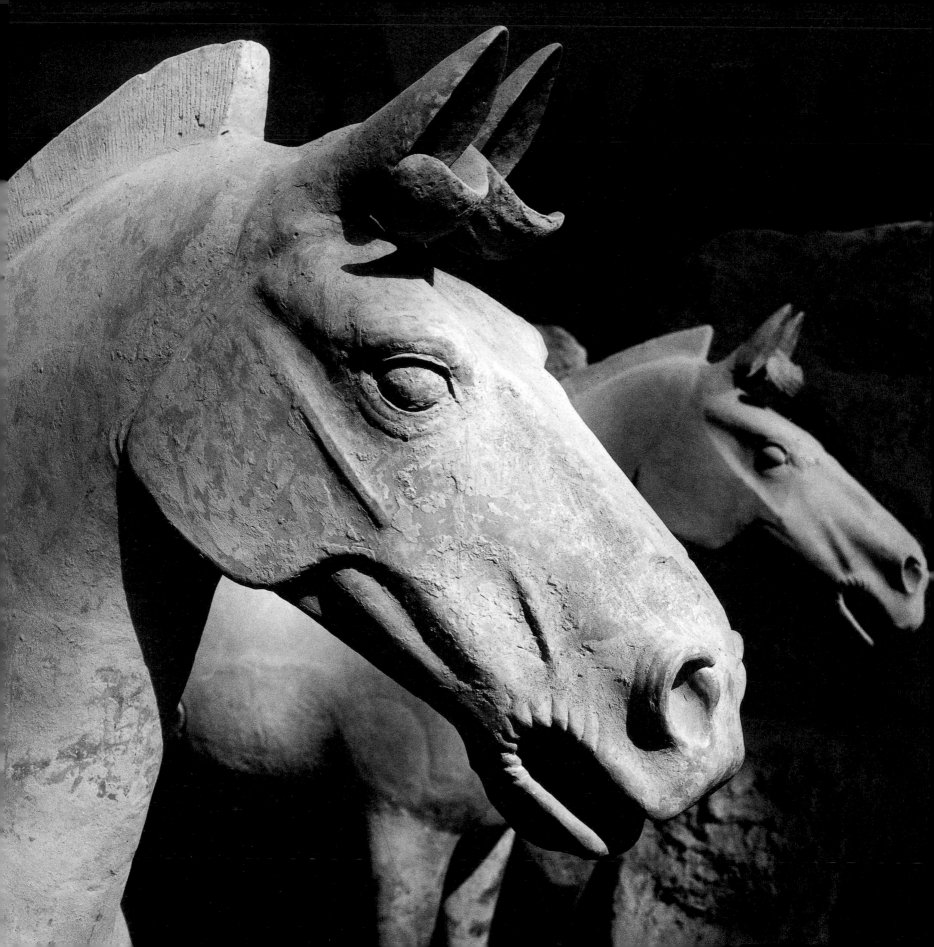

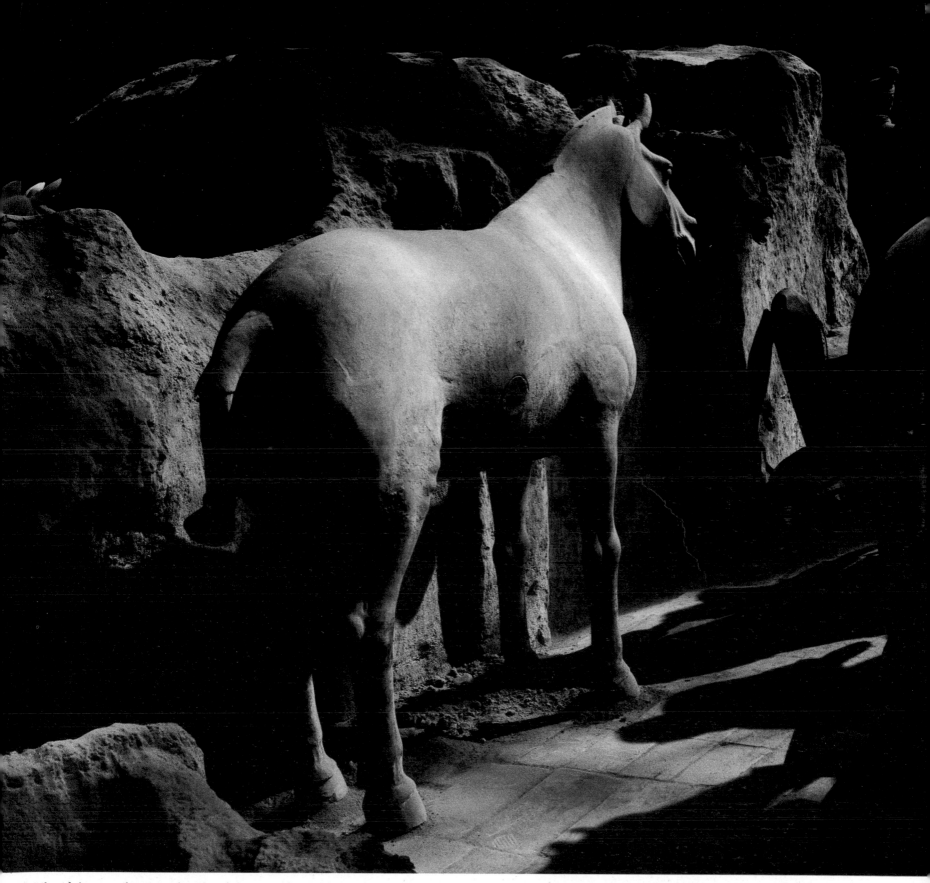

Heads of horses showing details of bone and muscle structure. Photo by Weng Naiqiang

Rear view of horse figure showing accurate representation of both form and spirit. Photo by Weng Naiqiang

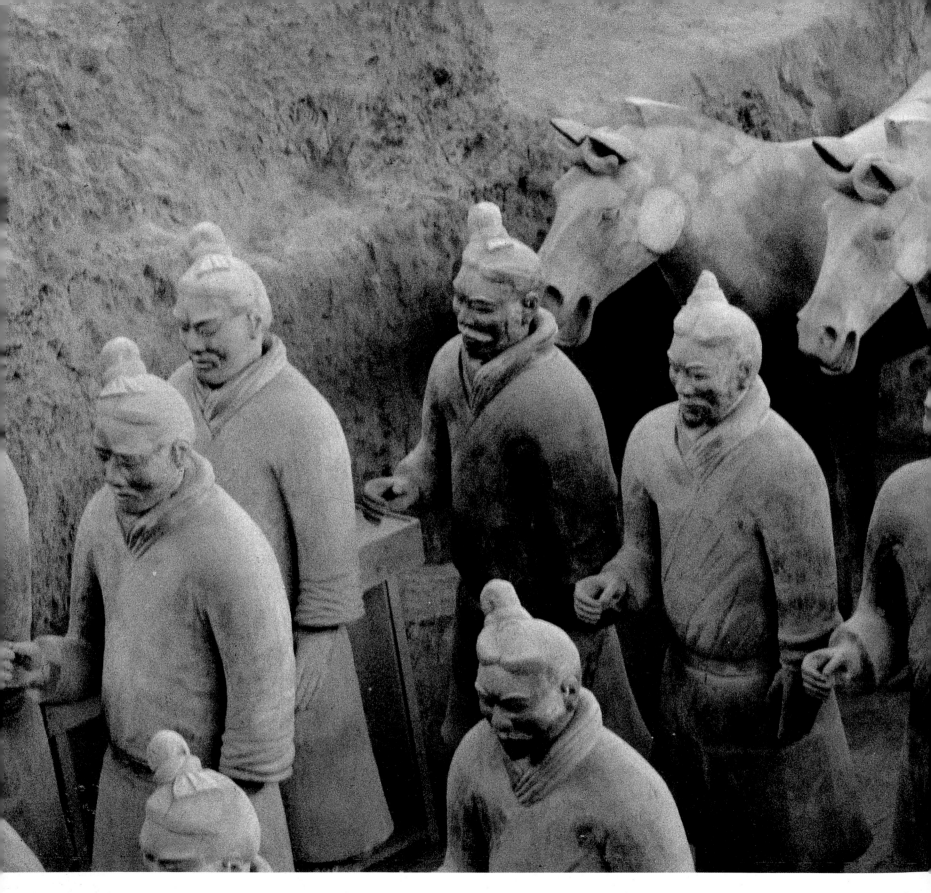

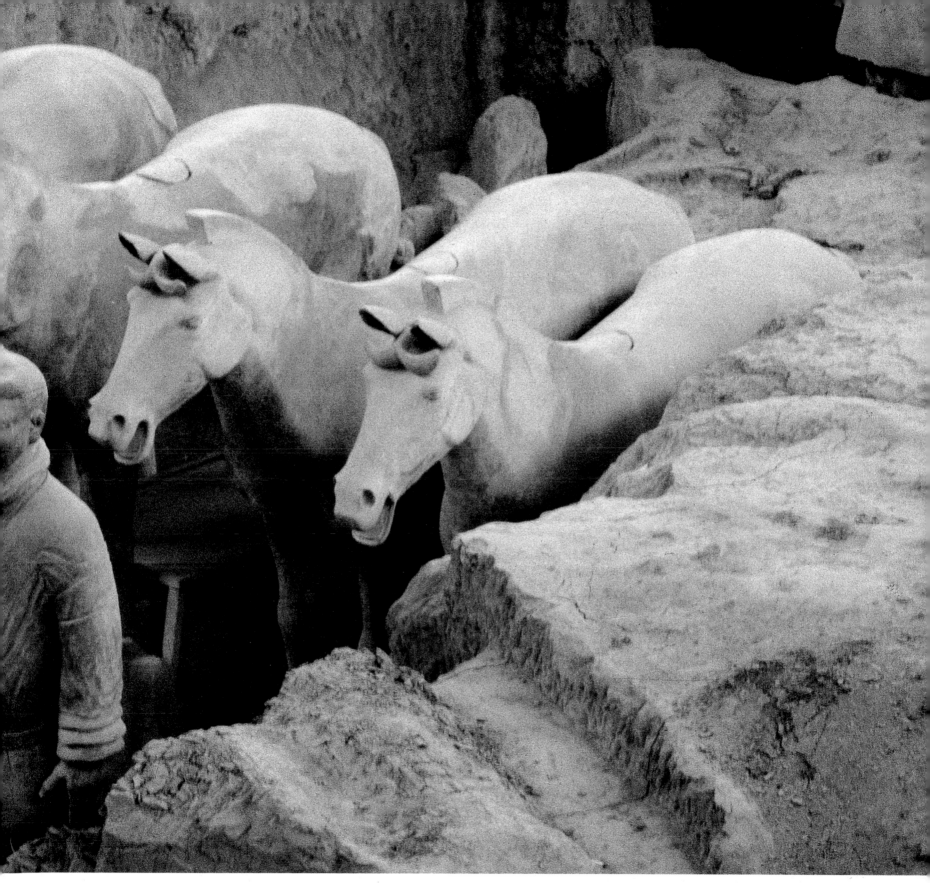

Robed warriors and chariot horses.

Photo by Weng Naiqiang

93

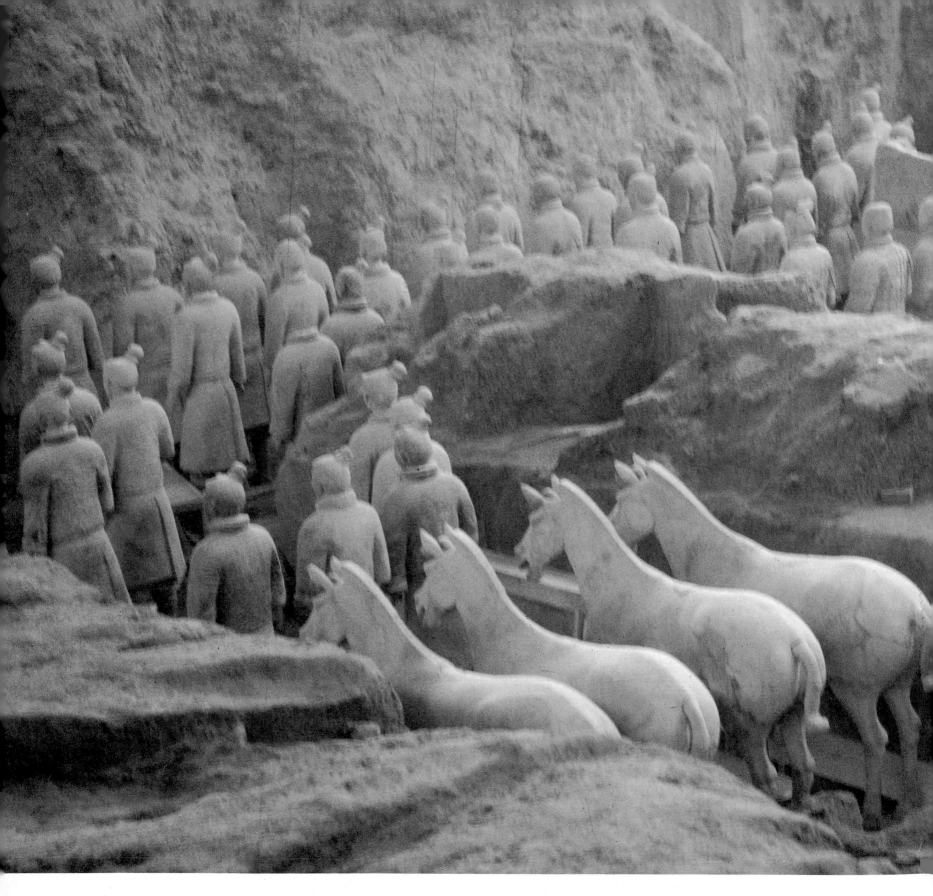

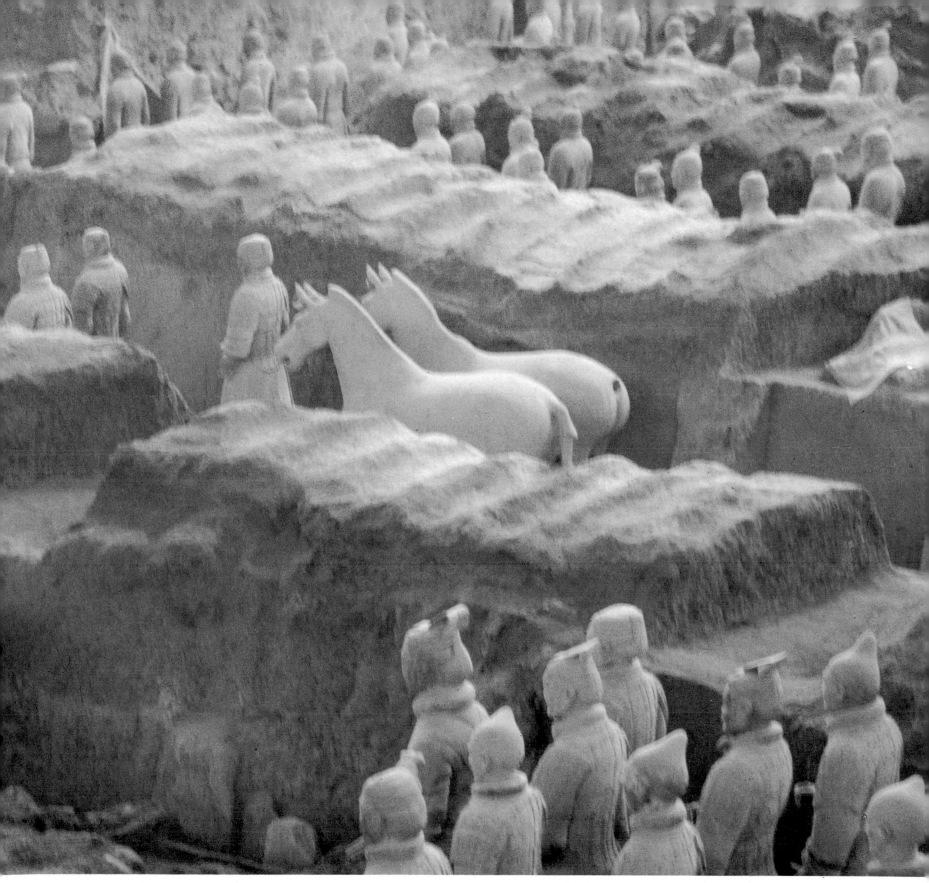

Side view showing the columns made up of infantry-men and horse-drawn chariots

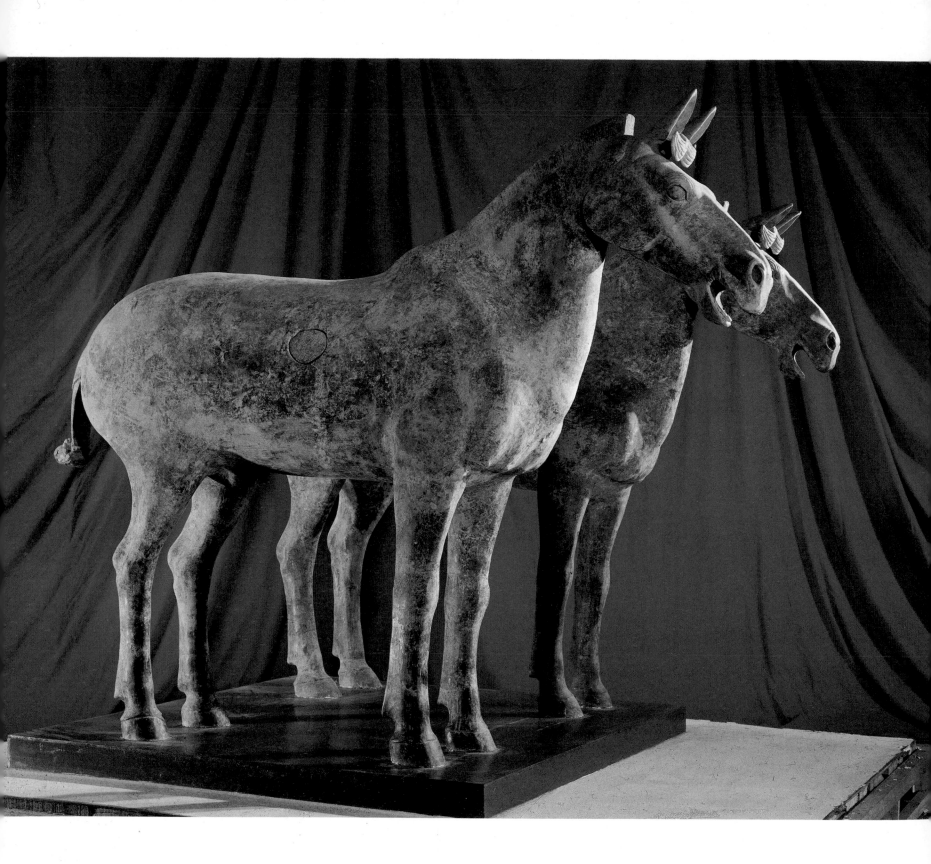

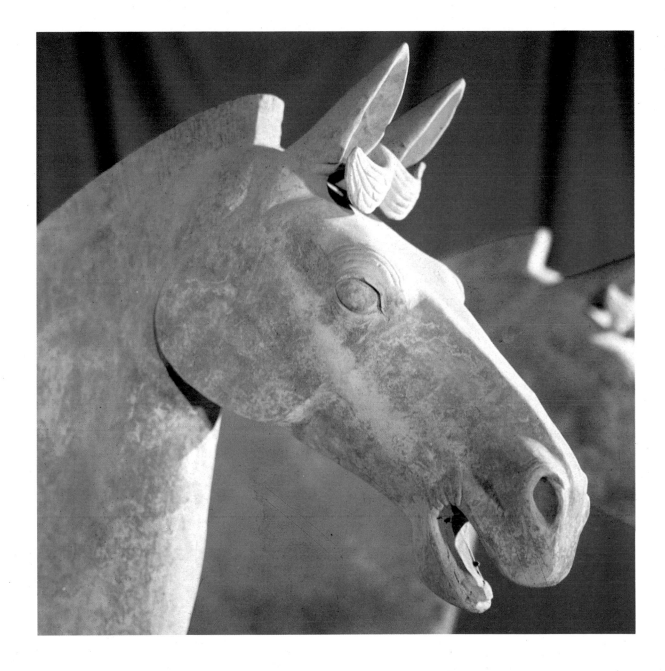

Close-up of a pair of horse figures.
Photo by Wang Lu

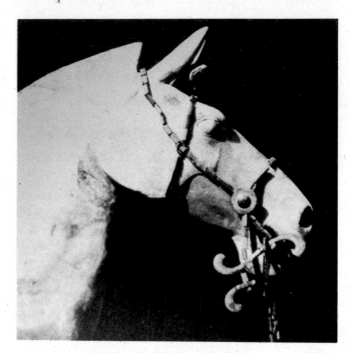

A bridled horse

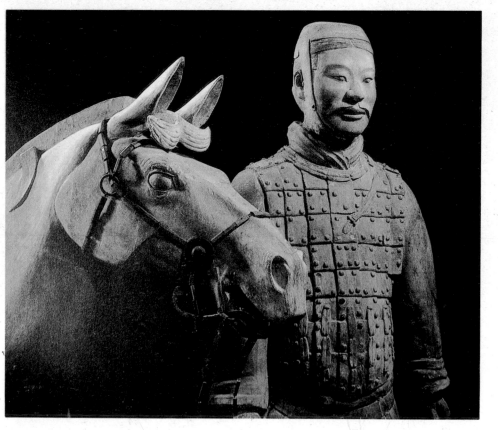

Cavalryman and horse

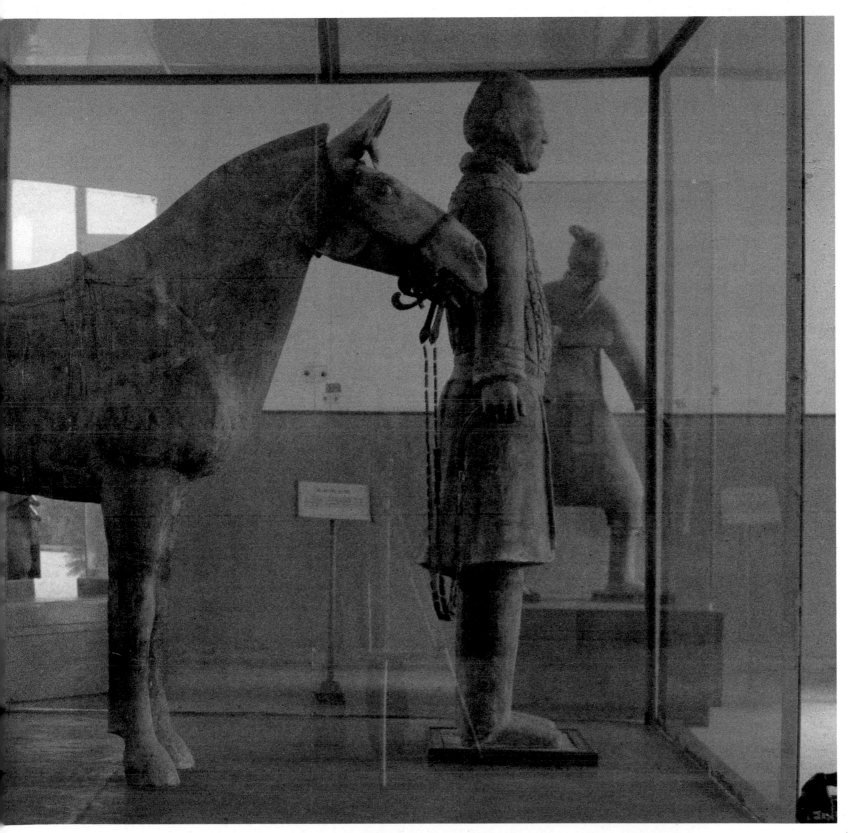

Cavalryman and horse on display in the exhibition room.

Photo by Weng Naiqiang

99

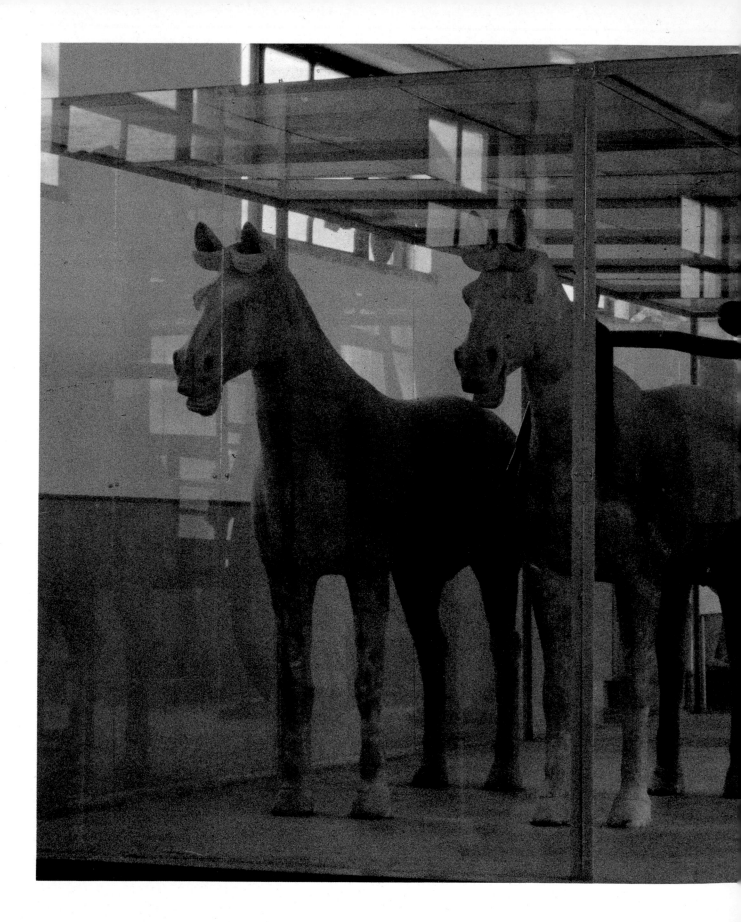

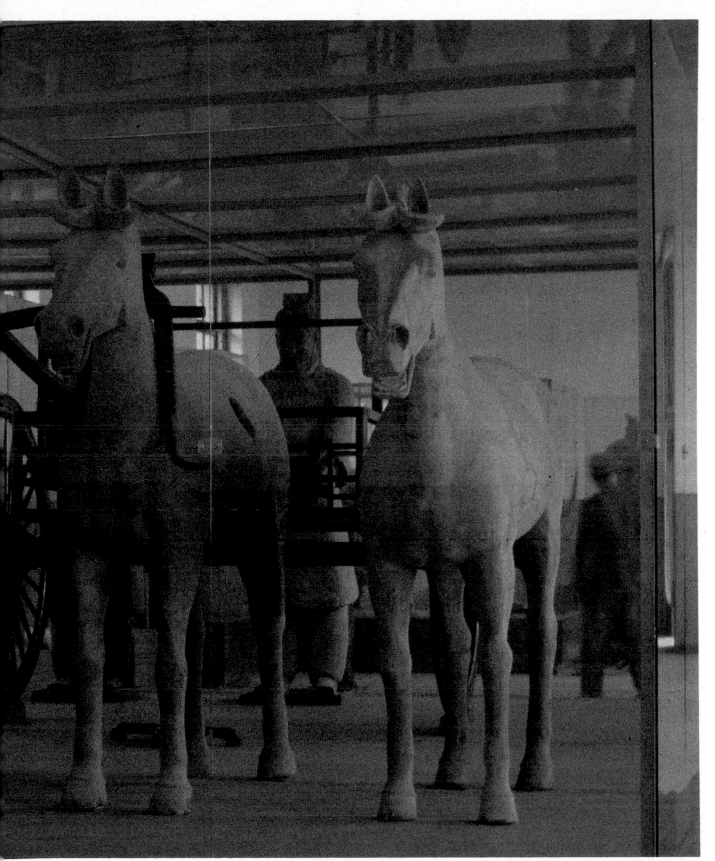

Fully restored chariot with a team of four horses on display in the exhibition room.

Photo by Weng Naiqiang

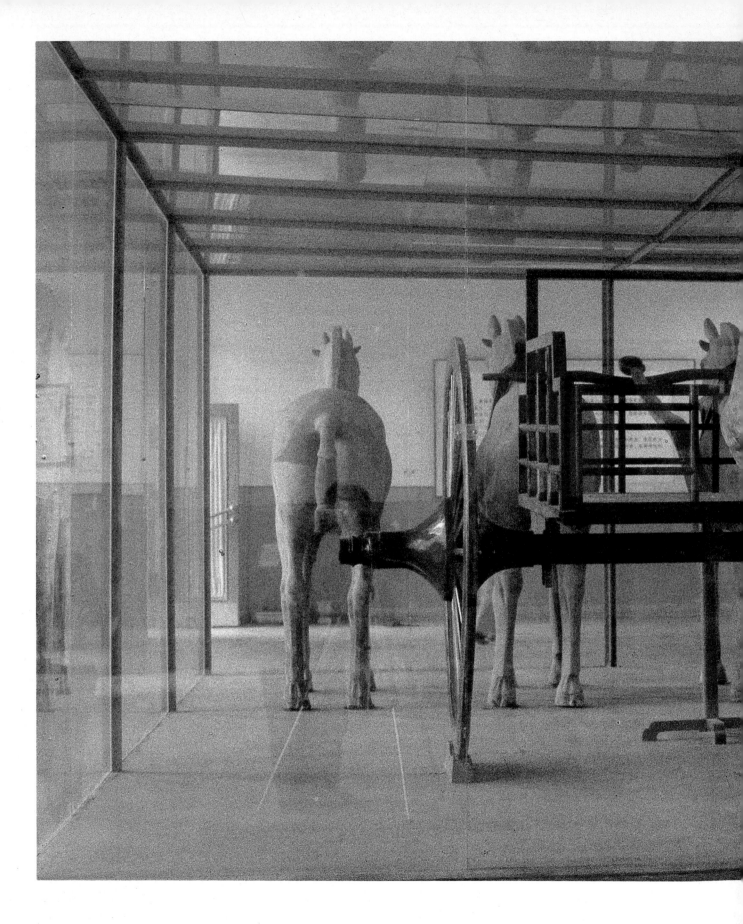

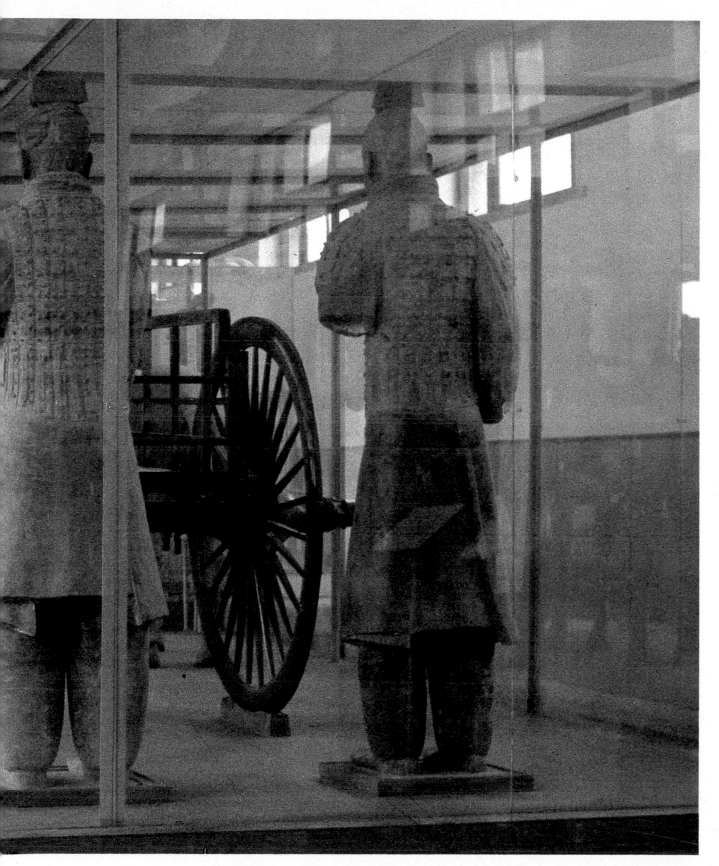

Rear view of fully restored chariot with a team of four horses displayed in the exhibition room.

Photo by Weng Naiqiang

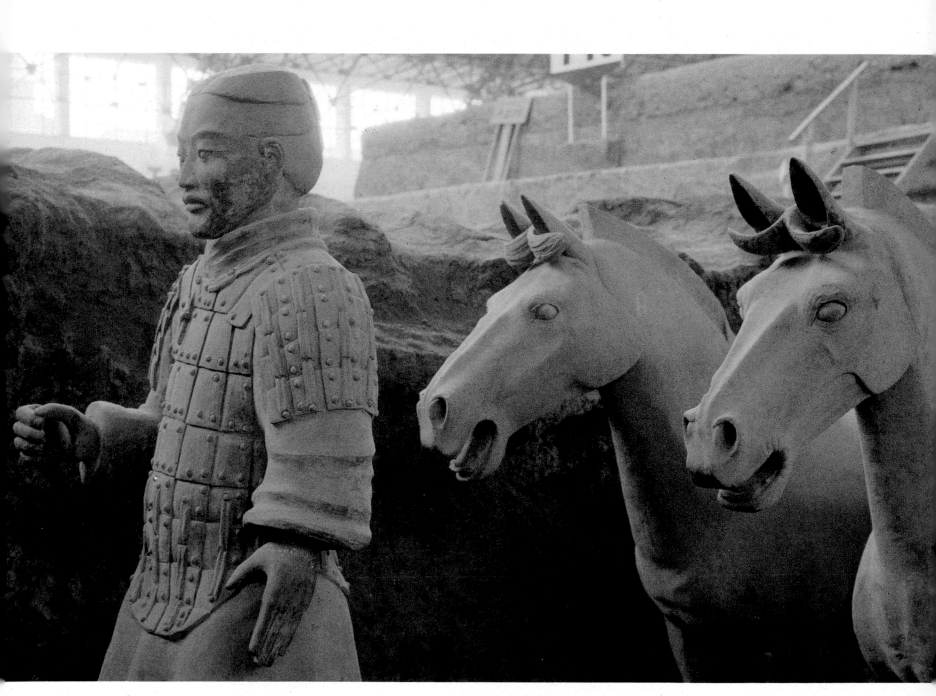

Chariot horses and cavalryman in the corridor.　　　Photo by Weng Naiqiang

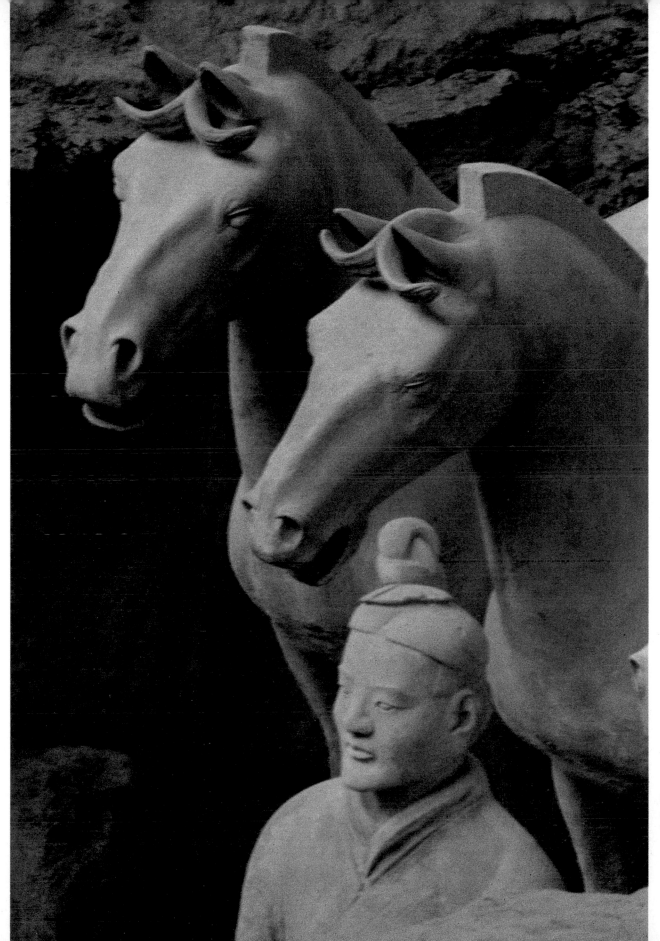

Qin Dynasty horses radiating strength and vitality.

Photo by Weng Naiqiang

105

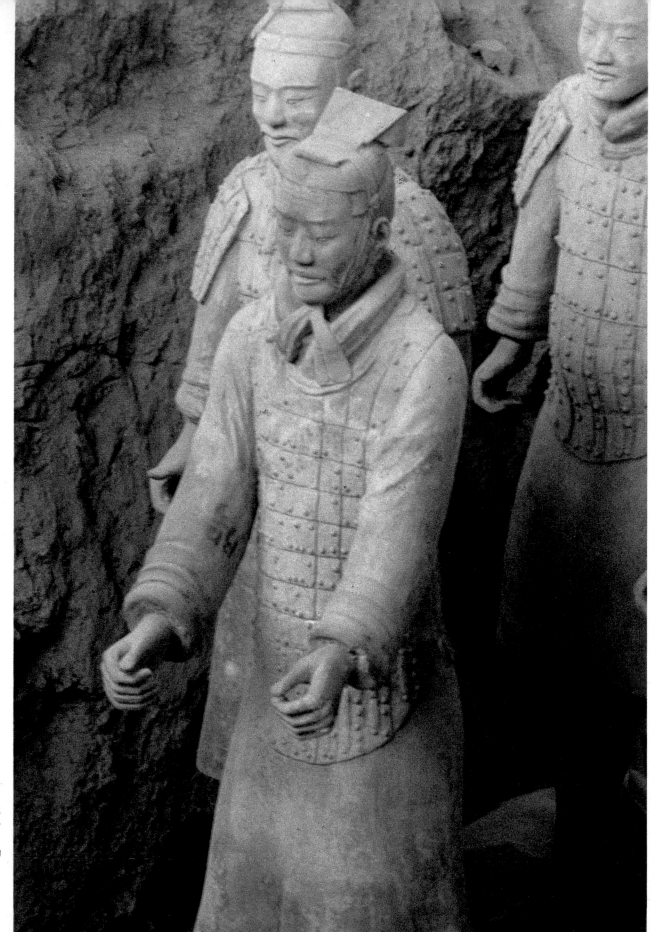

Charioteer bearing an expression of concentration.
Photo by Weng Naiqiang

5. Bronze Warrior and Horse Figures

In December 1980, a pair of bronze chariots, complete with horses and charioteers, was unearthed 17 meters to the west of the tomb mound.

The chariots were buried facing west one behind the other. The body of these chariots is 1 meter wide and 1.2 meters deep. The wheels measure 58 cm in diameter, their axles are 1.5 meters long, and each chariot has a shaft 2.5 meters long. A team of four matched bronze horses, two-thirds life size, is harnessed abreast to each chariot. The horses are 72 cm tall and 1.2 meters long. Their bodies were once painted in colors, but these have now faded to a greyish white. Their bridles are fitted with gold and bronze decorations. The sturdy horses, with their heads held high, appear healthy and alert. Each chariot is manned by a single charioteer; the one in the first chariot is kneeling and the one in the second is standing. Their bodies, also two-thirds life size, are entirely covered with decorative patterns.

These artifacts will require restoration before they are put on exhibition. According to archaeologists estimates, they were cast between 221 and 211 B.C., and are probably representations of a section of the stables attached to the underground palace in Qin Shi Huang's mausoleum. Judging from their headgear, the charioteers were most likely officials of the ninth rank (out of 20). It is surmised that chariots were modelled after the personal vehicles of either the empress, the crown prince or an imperial concubine.

The bronze chariots are some of the finest examples of Qin dynasty sculpture to have been unearthed to date. The precision, deicacy, and degree of realistic modelling seen in these specimens easily surpasses their terracotta counterparts. In addition, whereas the chariots in the terracotta army were made of wood and other materials that have long since decomposed, the bronze chariots and their accessories offer archaeologists a highly reliable source of information for the task of restoration.

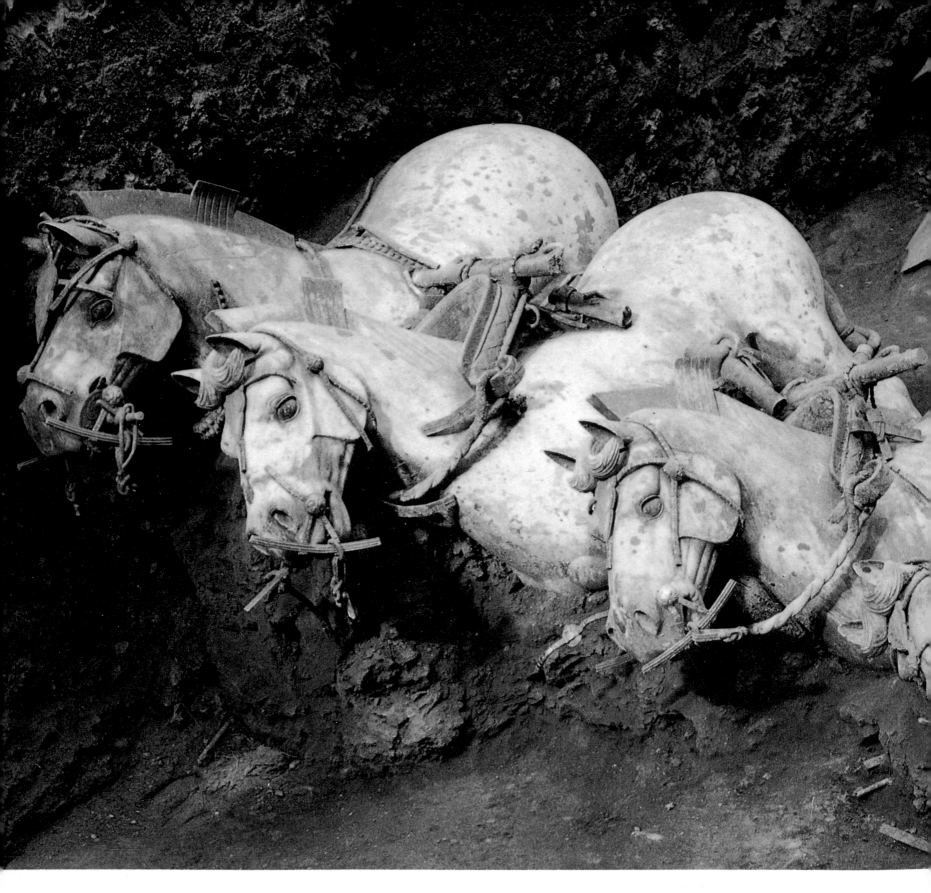

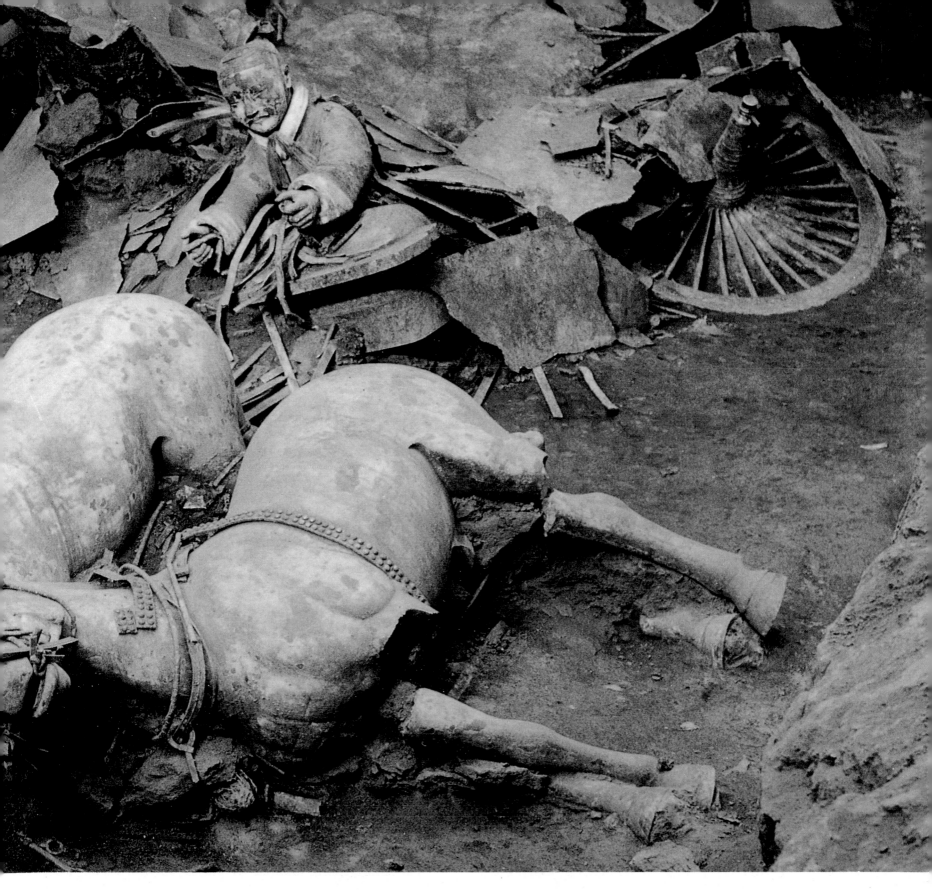

The excavation site of the bronze warrior and horse figures.

109

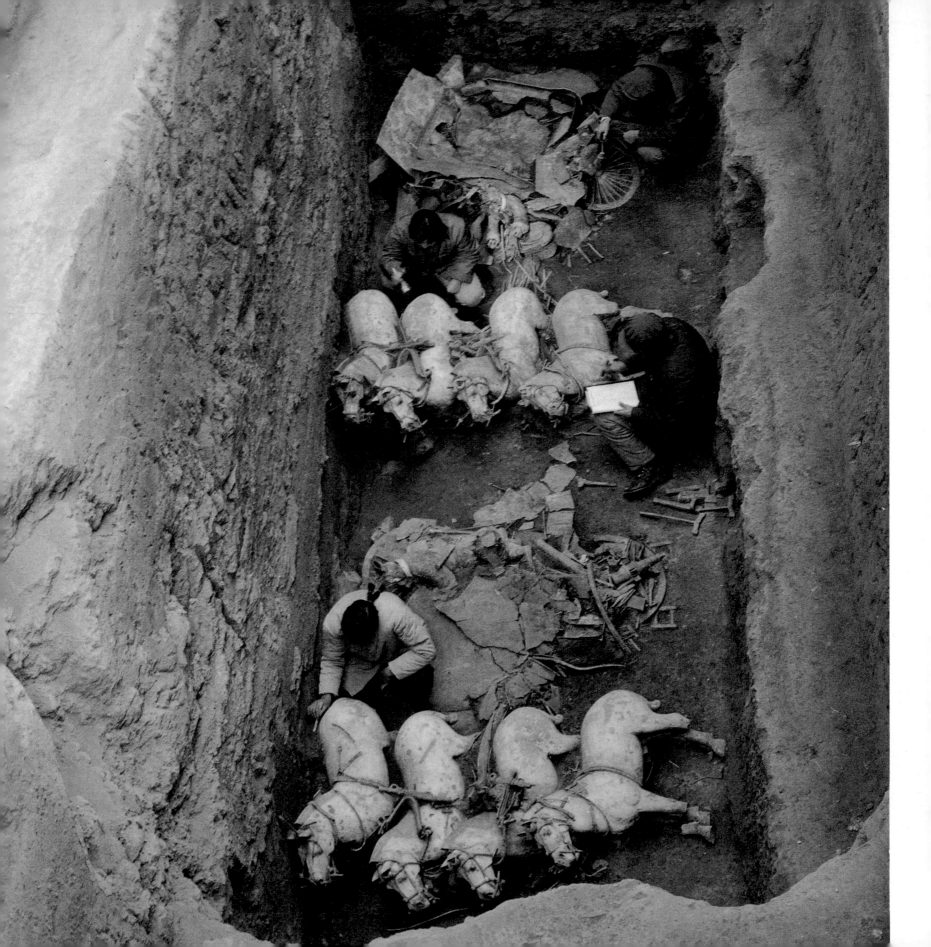

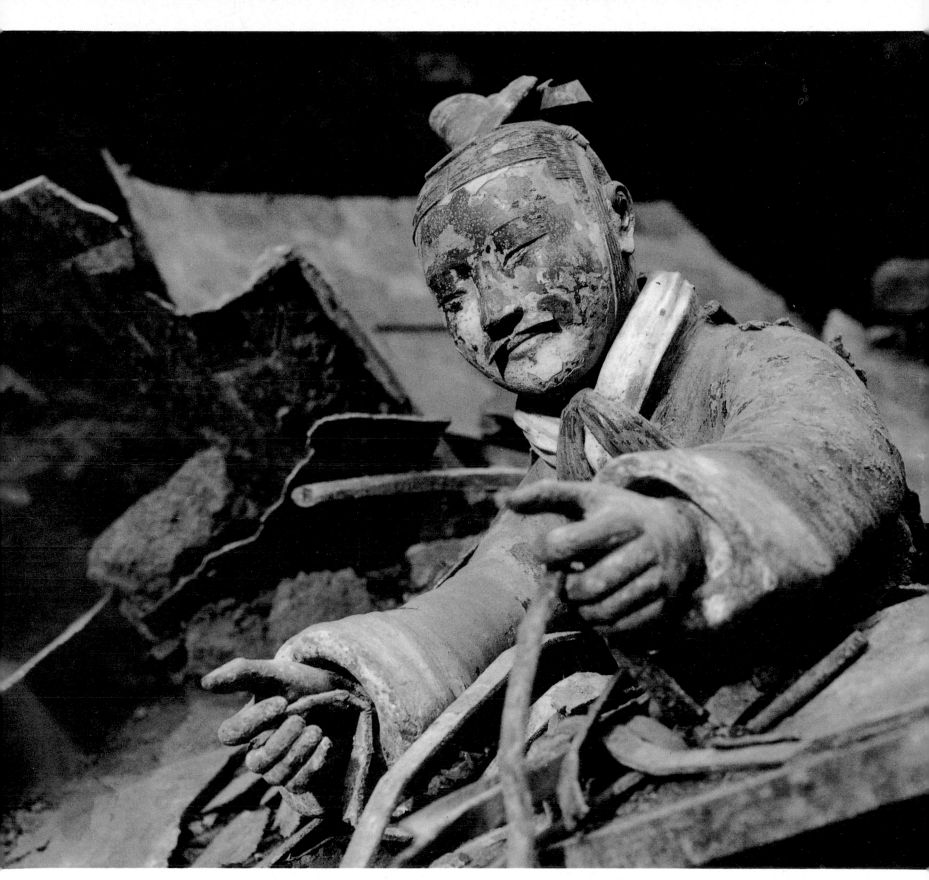

Archaeologists at work in the bronze warrior and horse figure pit.
Photo by courtesy of Xinhua News Agency

Bronze charioteer.
Photo by courtesy of Xinhua News Agency

111

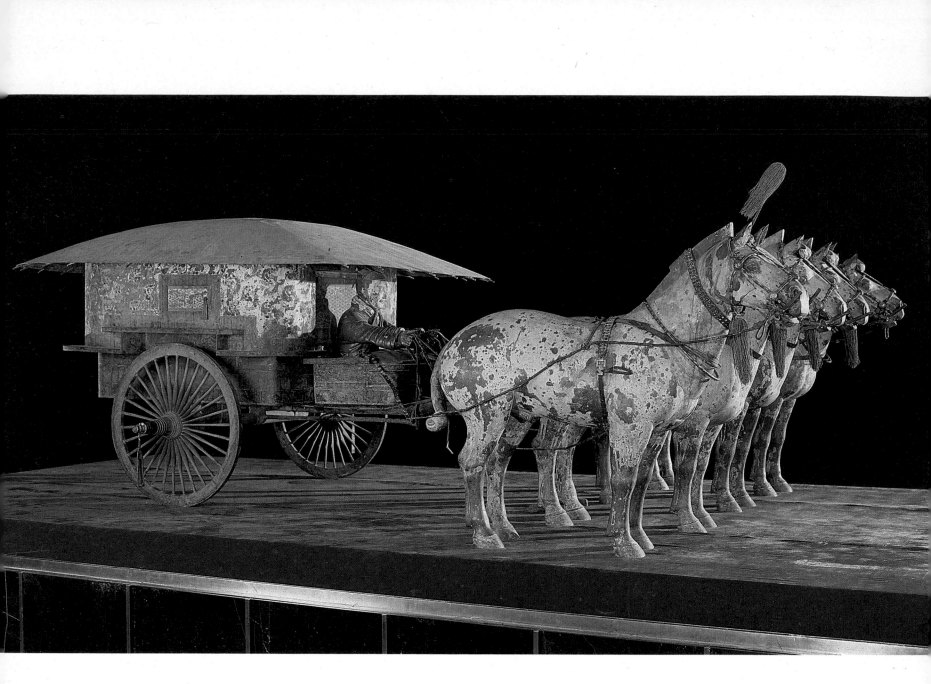

Fully restored bronze chariot with a team of four horses.

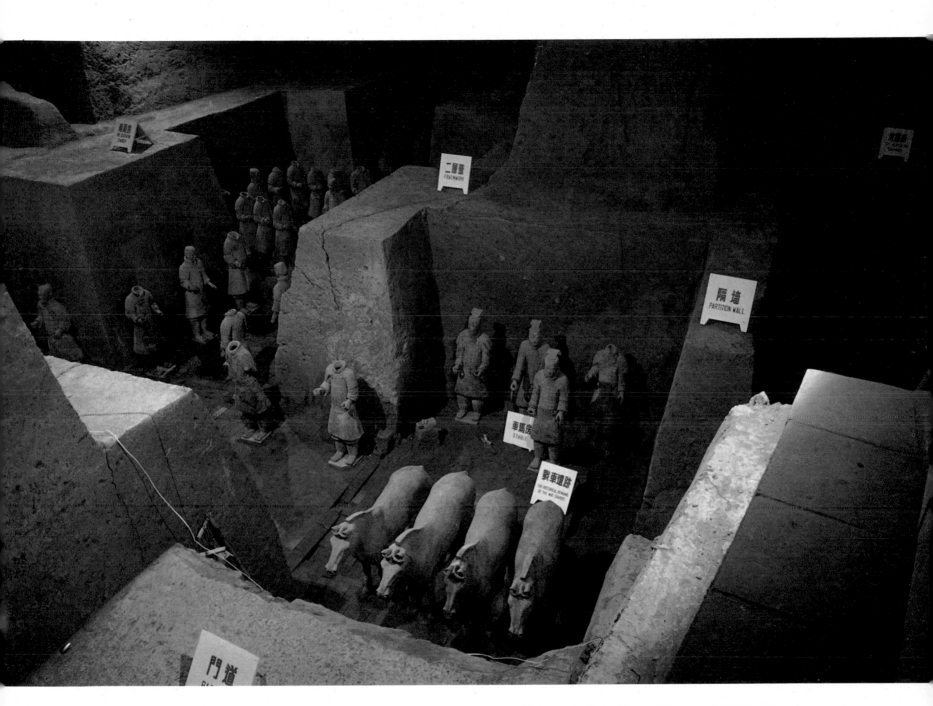

The room of chariots and horses of Pit No.III

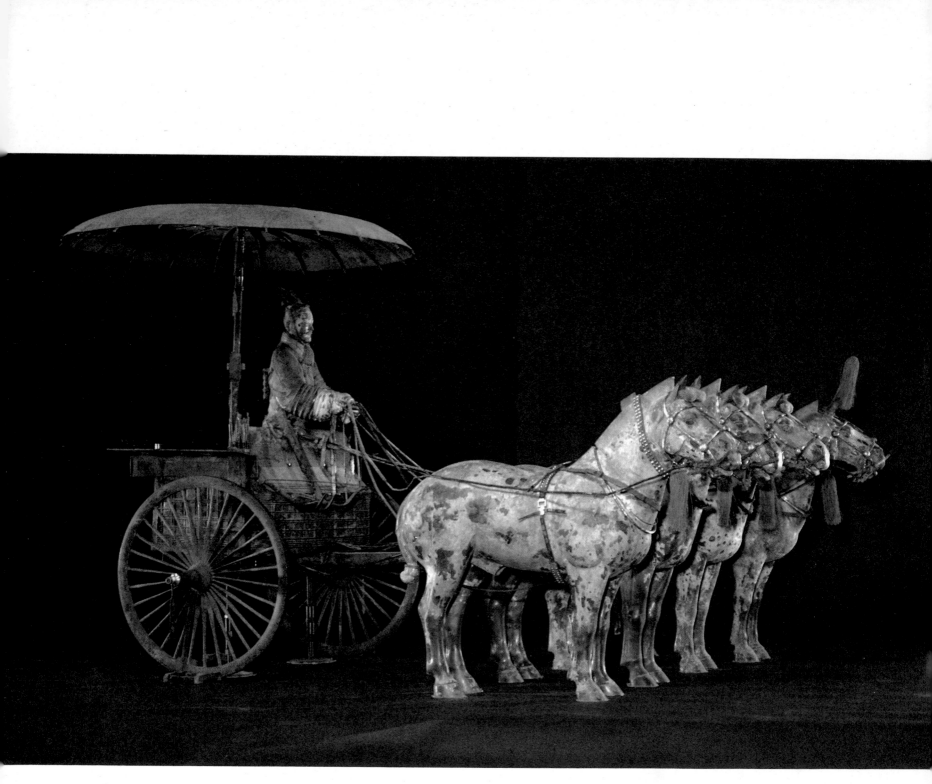

Bronze chariot of Pit No. 1

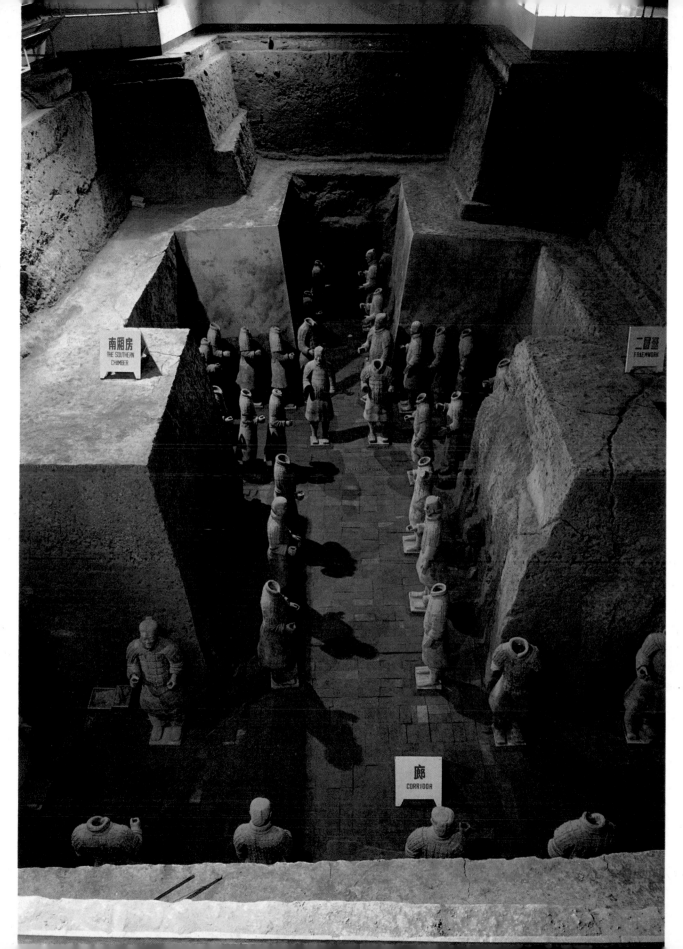

南厢房
THE SOUTHERN
CHAMBER

二号墓
FRAEMWORK

廊
CORRIDOR

The south wing of Pit No. III

115

秦 始 皇 兵 马 俑

编　著　傅天仇

装帧设计　李玉鸿

＊

新世界出版社出版

（北京百万庄路 24 号）

北京外文印刷厂印刷

中国国际图书贸易总公司发行

（中国北京车公庄西路 35 号）

北京邮政信箱第 399 号　邮政编码 100044

1985 年（英）第一版　　1992 年第五次印刷

ISBN7－80005－009－2

02900

85－E－218P